IMAGES
of America

BREVARD

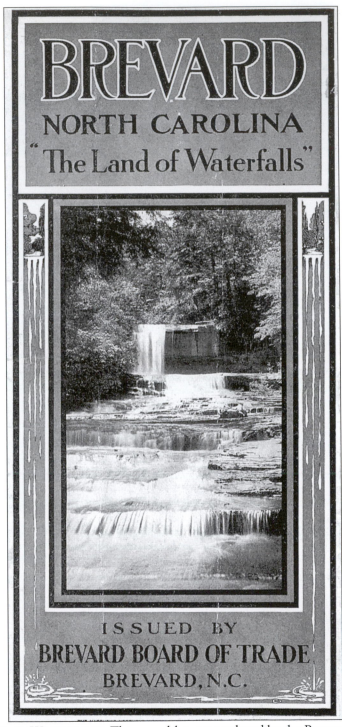

BREVARD

NORTH CAROLINA

"The Land of Waterfalls"

ISSUED BY

BREVARD BOARD OF TRADE

BREVARD, N.C.

BREVARD, LAND OF WATERFALLS. This pamphlet was produced by the Brevard Board of Trade in 1907. It invited tourists to enjoy the beautiful scenery, advertised the boarding houses and their prices, and enumerated all the excellent assets for business and industry, such as clean water and abundant forests. (Courtesy of Pat Austin.)

IMAGES
of America

BREVARD

Susan M. Lefler

ARCADIA

First published 2004
Reprinted 2004

Published by Arcadia Publishing
Charleston SC, Chicago IL, Portsmouth NH, San Francisco CA

Printed in Great Britain

Library of Congress Catalog Card Number: 2003115040

For all general information contact Arcadia Publishing at:
Telephone 843-853-2070
Fax 843-853-0044
E-mail sales@arcadiapublishing.com
For customer service and orders:
Toll-Free 1-888-313-2665

Visit us on the internet at http://www.arcadiapublishing.com

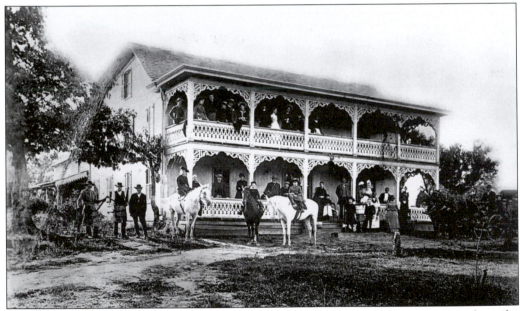

D. GOWER HOTEL. Located in Cedar Mountain, this hotel hosted summer visitors from the Lowcountry long before the Civil War. The D. Gower family were the first summer residents in Transylvania County and built a home in Cedar Mountain in the late 1700s. D. Gower then built this hotel located across from "Hi Bunyan's" Store. When prospective guests crested the hill, they blew their hunting horns to announce their impending arrival. The hotel no longer stands. (Courtesy of Vera Jones Stinson.)

CONTENTS

ACKNOWLEDGMENTS

This volume is not intended to be a comprehensive history of Brevard, but rather a loving sketch of a variety of people and events from its rich and fascinating history. Brevard has been blessed with some remarkable professional photographers, including Joseph Wilde, William Austin, and R. Henry Scadin, who carefully recorded the history of both town and county. The Transylvania County Joint Historic Preservation Commission with its archives collection (begun by Rowell Bosse) has made this project possible. Without Betty Sherrill ("mother of the archives"), I could never have pulled these photographs together. Volunteers at the archives, especially Sue Sharpe and Jan Osborne, were excited about the project and helped me with research. The Transylvania County Historical Society lent enthusiastic support, and I am grateful to Jill Chapman and Jack Reak for their encouragement. Pat Austin, who, along with her father, took many of these wonderful photographs, has been a constant, knowledgeable, and gracious resource, as has her brother Bill Austin. The Joseph Stokely Wilde family, especially his daughter Dorothy Galloway and his granddaughter Laura Britton, lent me their collection of his photographs and shared historic details and family stories with me. Mike Curtis scanned over 100 photographs, and Will Sagar came to the rescue with computer crises. I am grateful to the many Transylvania County natives who offered their stories, historical perspective, and photographs: Vera Stinson, Jim Morrow, Mac Morrow, Judge Robert Gash, Becky Huggins, Jack Hudson, Joe Orr, Selena Robinson, Stella Trapp, Nathaniel Hall, Bill Tinsley, the Jim Bob Tinsley Museum, Dottie Vaniman, and others. My thanks to friends for their editorial advice, including Paula Benton, Suzanne Bell, Donna Warmuth, Jeannette Cabanis-Brewin, and especially Anna Robinson, without whose expertise I could not have made it through the final phase of this project. I am also indebted to Laura New and Maggie Tiller, editors at Arcadia Publishing. And finally, I am grateful to my husband, children, and grandchildren, who encourage me no matter what.

CREDITS FOR THE PHOTOGRAPHS UNLESS OTHERWISE NOTED:

HPC: Historic Preservation Commission
MJM: The Mary Jane McCrary Collection

AC: The Austin Collection
WILDE: The Joseph Stokely Wilde family

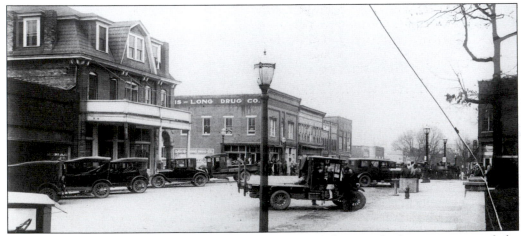

BREVARD'S CITY CENTER. William Austin took this photograph from just east of the courthouse looking toward the intersection of Main and Broad Streets. (AC.)

INTRODUCTION

The first residents of the area that would become Brevard were the Cherokee people. Their ancestors probably settled in the region of Connestee as early as 200 to 400 A.D. France claimed this region from 1682 to 1763, giving the French Broad River its name. The territory then came under English control until the end of the American Revolution. Cherokee towns and culture in this period are beautifully described in William Bartram's accounts of his travels in the 18th century. At that time, no borders were defined between North and South Carolina. Cherokee villages called "Eastatoe" existed in what is now South Carolina and Georgia. Cherokee hunting parties gathered near the headwaters of the Davidson River each fall and traveled along hunting paths that ran through the region of Transylvania County. Eastatoe came to be the name associated with these hunting routes, one of which ran through Rosman (once known as Eastatoe). The routes were later used by settlers to drive stock (turkeys, pigs, and cattle) from the West through the mountains to markets such as Greenville, Columbia, and Charleston in the East. These stock drives continued until the railroad came to Brevard in 1894. The Cherokee civilization was nearly destroyed by the tragic removal of the Cherokee Nation to Oklahoma in 1838 on the "Trail of Tears."

By the mid-18th century, a few Scots-Irish settlers had begun to move into the area. John Brevard and brothers John and George Davidson settled near the river known as "Davidson's Creek," which runs down out of the mountains near the entrance to Brevard and would become known as the Davidson River. John Brevard's daughter Nancy married George Davidson's son John. The couple was later massacred by the Cherokee, but their daughter Sarah was saved by her black nurse Phillis Davidson. Sarah was raised by her aunt Mrs. Ephraim Davidson and later married Lambert Clayton. These families were closely tied by marriage and their descendants would go on to found Brevard. John Gillespie of Gillespie Rifle fame (a gun known as the most accurate long rifle in the world) moved to the East Fork of the French Broad River in 1800 and later to the Mills River area.

Brevard was founded as the county seat of Transylvania County at a rather desperate time in our nation's history. In 1861, just as the county was designated and a meeting formed to choose the name and location of the county seat, North Carolina became the last southern state to secede from the Union. With opposition to secession widespread in the western part of the state, many Transylvania County families found themselves with divided loyalties between Union and Confederacy. In addition, the county's mountainous terrain offered a haven for deserters. They formed gangs of outlaws who created havoc in the county, robbing and even murdering its citizens and burning property.

It took time to recover from the ravages of the Civil War, but with the coming of the railroad in 1894, Brevard began to experience a new prosperity. The natural resources found in the area, particularly the clean water and the abundant timber, drew industrialists who developed the huge logging industry along with the tanning industry that accompanied it (tannin was extracted from the bark of the logged trees and used to tan animal skins). Joseph Silversteen, who had immigrated from Russia at age five, moved to Transylvania County from Pennsylvania at the turn of the century. Silversteen founded Gloucester Lumber Company as well as tanning companies in Rosman and Brevard. An Italian immigrant named Louis Carr established one of the largest band saw mills in the state. He owned the timber rights in Pisgah National Forest from 1915 to 1930. In addition, the beauty of the area with its many waterfalls and creeks, the grand French Broad River, and the innumerable mountain vistas and cool climate continued to attract tourists.

With the completion of the railroad to Lake Toxaway, this exquisite environment became accessible to people from all over the country. Francis Hayes, also from Pennsylvania, founded the Toxaway Company in 1895 and went on to build Lake Toxaway and a luxury hotel described as the "Switzerland of the South." He helped develop a huge tourism industry that brought lovely hotels, like the Franklin, to Brevard and allowed its residents to offer their homes as boarding houses.

Brevard has been blessed with a deeply vital spiritual history as well as a strong tradition of local schools and a college. It has benefited from traditional mountain heritage, craft, music, and dance, as well as from the classical traditions celebrated at its internationally known Music Center and at Brevard College with its strong music program.

But most of all, Brevard's identity has been formed by the remarkable people who have lived here and worked to make it better. The African-American community has been from the earliest days a vital part of Brevard's development and character, leading the way in school integration, for instance. Brevard has birthed nationally known entertainers such as Moms Mabley and Beulah Mae Zachary. Its citizens have been war heroes, road builders, writers, craftspeople, carpenters, lawyers, physicians, business owners. . . . The list goes on and on and their stories are rich and varied. We invite you to immerse yourself in moments captured by photographers like Joe Wilde and William Austin, who must have sensed the importance of people, events, and scenes that probably seemed unimportant to most folks. Or maybe they did seem extraordinary and people were too busy living and working to worry with images that might go into books one day. In any case, those of us who cherish this history are grateful to those who took the pictures, made the notes, saved the pictures, and remembered the stories. Without them we would be impoverished.

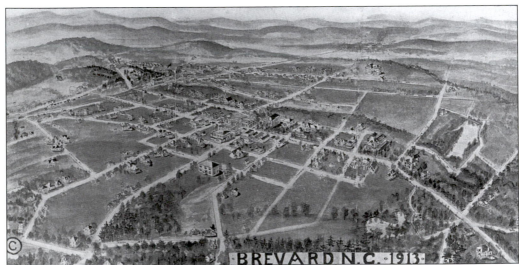

BREVARD, NORTH CAROLINA. ". . . Haunted by the ringing of train bells . . . the sound of whistles fading away somewhere along the French Broad River . . ." Thomas Wolfe wrote these words about his mountain childhood in a letter. In the 1930s, he often visited his novelist friend Hamilton Basso at Basso's home on the French Broad River just outside Brevard. The words seem to fit this 1913 view looking down on Brevard from one of the surrounding mountain ranges. (Courtesy of Pat Austin.)

One
BIRTHING A TOWN
Complications of War

Transylvania County was established in February, 1861. The town site and county seat were chosen by Leander Gash, Alexander England, and Braxton Lankford on May 28, 1861, only eight days after North Carolina seceded from the Union. They met at a trading post known as "Poor's Store," which is now the Red House on Probart Street. The three men gave 50 acres each and drew up the plan for downtown Brevard. They specified that the county seat was to be located within one-third mile of the store. As in other parts of the South, the Civil War created great difficulties for the fledgling town. There were no big plantations and fewer than 500 slaves, so many families were divided in their loyalties between the Union and the Confederacy.

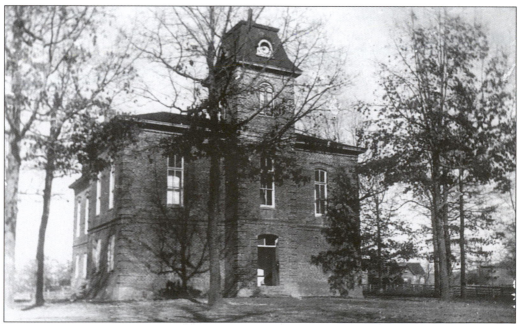

TRANSYLVANIA COUNTY COURTHOUSE. Because of the Civil War, plans for a brick courthouse had to be delayed. A two-story frame structure was completed in 1866. The existing brick courthouse, designed by Thomas W. Davis, was completed in 1881. The building is an example of Italianate Victorian architecture. The basic plan remains as it was originally designed.(HPC.)

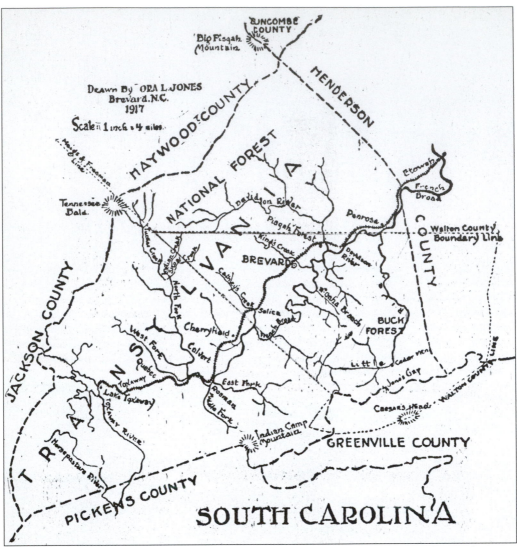

TRANSYLVANIA COUNTY MAP. The map shows Walton County, area of the dispute between Transylvania County and Georgia that culminated in "The Walton Wars" after the county was incorporated by the Georgia legislature in 1803. Place names mentioned throughout the text can be identified on this map. (MJM.)

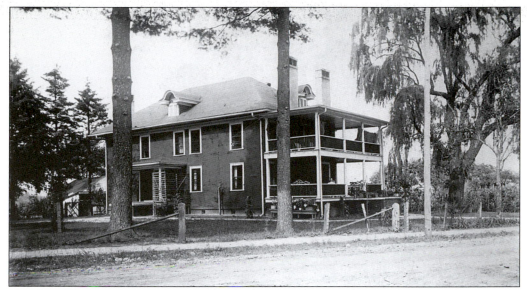

THE RED HOUSE. This structure was first built as a trading post by Leander Sams Gash in 1851. The storekeeper was W. Probart Poor and it was known as "Poor's Store." It was the first house in what was soon to become Brevard and also served as Brevard's first post office. In the earliest plan for Brevard, the street was called "Poor Street," but that displeased some residents and it was renamed "Probart Street." In the latter part of the century, the Red House housed The Epworth School, which would become Brevard Institute. (MJM.)

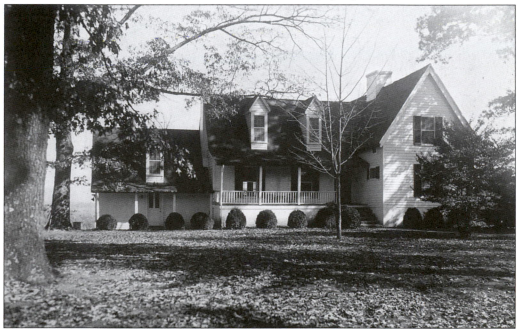

LANKFORD-CLEVELAND HOUSE. Built in 1858, the oldest part of this home belonged to Braxton C. Lankford, who helped to found Transylvania County and Brevard. Located on North Rice Street behind the Brevard-Davidson River Presbyterian Church, this is the second oldest house in Brevard. The house, modeled on Montclove (see page 14), was acquired by the Cleveland family in 1913. (AC.)

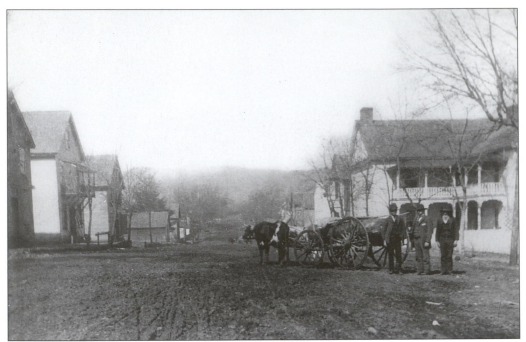

MAIN STREET WITH McMINN HOUSE, 1886. Brevard's main street was still unpaved in the mid-1880s; dust or mud was a constant fact of life. From left to right are Jim Paxton, Wait Gash, and Alexander England. (HPC.)

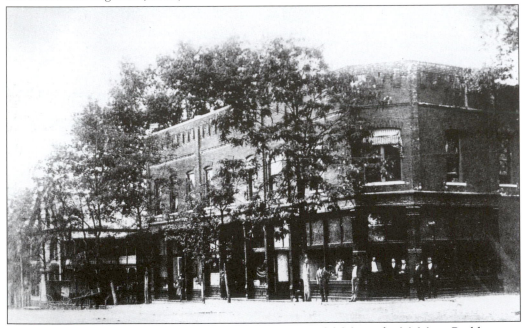

McMINN BUILDING. Built in 1899 by Nathan Van Buren McMinn, the McMinn Building was the first brick commercial structure in Brevard. This local merchant wrote to his son in 1898 saying he planned to build a "good brick building on the corner this fall and save rent." He built it next to his own home, visible at left. The building still stands on the corner of West Main and North Broad. (AC.)

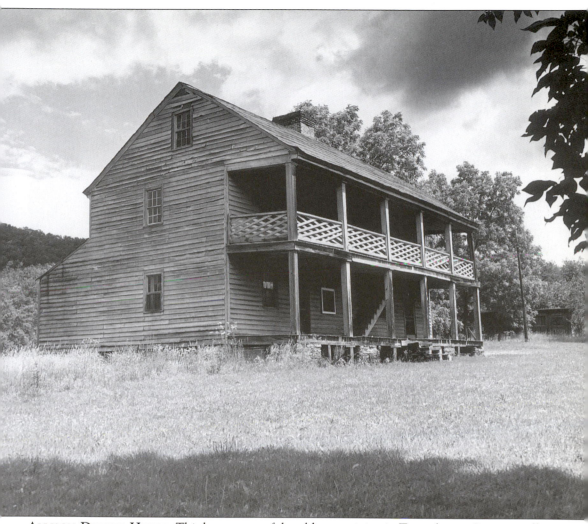

ALLISON-DEAVER HOUSE. This house, one of the oldest surviving in Transylvania County, still stands near the entrance to Pisgah National Forest just outside of Brevard. Recent research indicates that a portion of the existing house may have been built as early as 1812 by Benjamin Allison. It is the oldest extant frame house in Western North Carolina, a refinement compared to the log cabins common to these frontier settlements. The home was purchased by William and Margaret Deaver in 1834. Deaver was one of the men assigned to the task of planning the brick county courthouse. At the age of 71, Deaver was shot to death on the porch of his home in 1865 by a band of "bushwhackers" (Civil War deserters) who were looking for his son, Capt. James Deaver. (AC.)

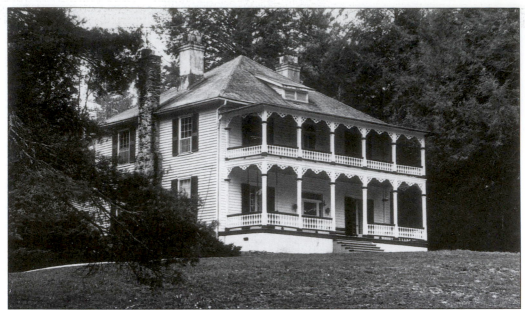

CHESTNUT HILL. Built just prior to the Civil War by the Reverend James Stuart Hanckel of Charleston, South Carolina, Chestnut Hill is one of many examples of the close connection of wealthy families from lowcountry South Carolina to the western tip of North Carolina. Reverend Hanckel officiated during the Civil War at the newly formed Episcopal mission called St. Paul's in the Valley, which later became St. Philip's Episcopal Church in Brevard. (HPC.)

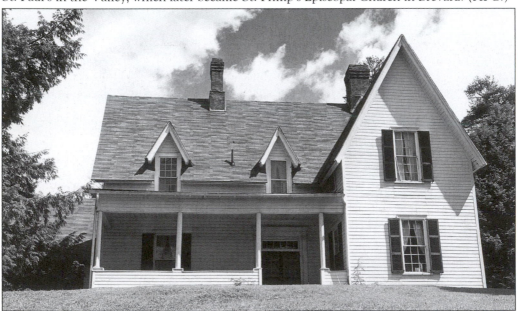

MONTCLOVE. This is the summer home of Francis Withers Johnstone, built in 1854. Montclove stands just across the French Broad River from Chestnut Hill. The first Episcopal congregation in the county held its service at Montclove with the Reverend James Hanckel (who built Chestnut Hill) officiating. Many people arrived at church by way of flat bottom boats. Montclove was sold to the Gilfillen family during the Depression and still exists off Deerwoode Lane on a hill overlooking the French Broad River. (AC.)

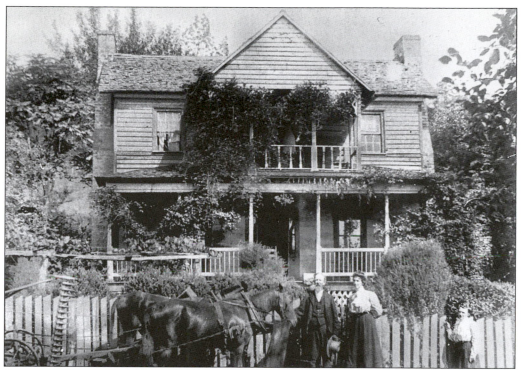

CLAYTON VILLA. Home of John Clayton, this house was built in 1826 on the French Broad River in Claytonville, near Penrose. Lambert Clayton was postmaster of the Claytonville Post Office, established in 1807. It was the first post office in the region. (MJM.)

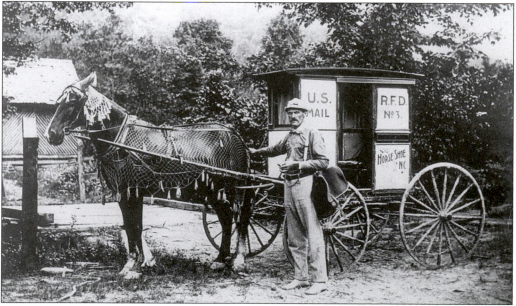

U.S. MAIL AT THE TURN OF THE 19TH CENTURY. Jesse O. Johnson delivered the mail from Horseshoe to Brevard. Jesse's mother made the net for the horse to keep off the flies. Another mail route, from Mills River to Brevard, took three days to traverse. The earliest known mail carrier in Transylvania County was an African American named Andy Whitesides. (HPC.)

HUME HOTEL RUINS. The Hume Hotel, also called the Rock or Stone Hotel, was the first hotel built in the county. Located on what is now the Greenville Highway at Dunn's Rock, the hotel was burned by bushwhackers during the Civil War. Mrs. Hume was warned that the gang planned to burn her home and she managed to escape up the mountain with her silver and a few possessions. At the top of Mill Hill, she turned her wagon around and watched from above as her hotel burned to the ground. (MJM.)

MAXWELL HOUSE. Soldiers departed for the Civil War from this house, which was built by Lambert C. Neill. Few people in and around Brevard had large landholdings or slaves, so conflicting loyalties divided many families. Some had sons and husbands who fought on different sides of the conflict. Miss Mary Neill married Robert Maxwell and is still remembered by Brevard natives. Maxwell House was nicknamed "Apple Grove." (AC.)

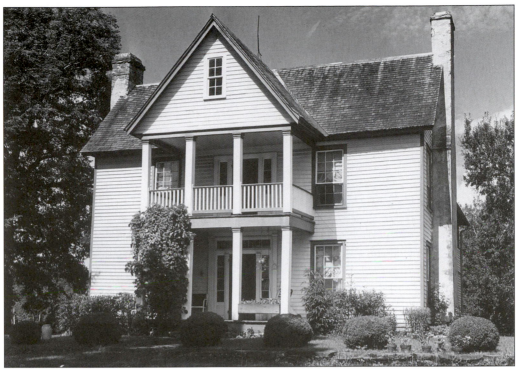

FLEM GALLOWAY HOUSE. John Fleming "Flem" Galloway built this home in 1878 in the Calvert vicinity. Family tradition held that he based his house plan on homes he had seen in Virginia while serving in the Confederate Army. (AC.)

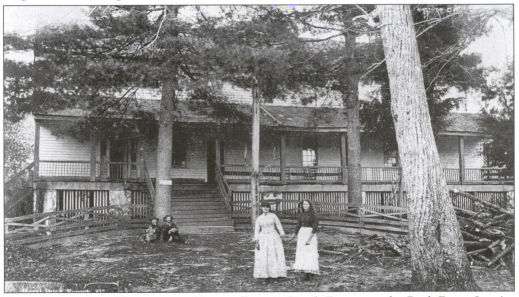

BUCK FOREST INN. The owners of Patton Farm in Pisgah Forest ran the Buck Forest Inn (or Hotel) located in the southwestern part of the county. Built in 1860, it was the second hotel in the county and became a stagecoach stop on the Greenville-Asheville route. The hotel burned in about 1900. One story is that the caretaker confronted poachers who then murdered him and burned the inn down to conceal the crime. (MJM.)

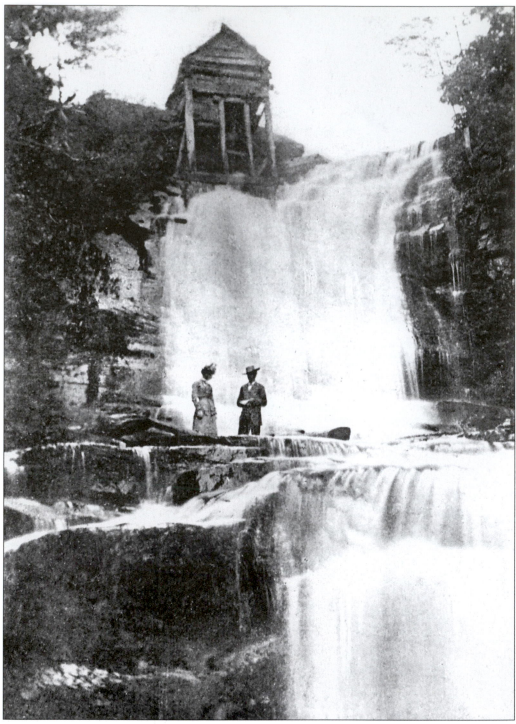

SUMMEY'S MILL ON CONNESTEE FALLS, C. 1910. Built by Lewis Patton Summey in 1870, Summey's Mill was perched at the top of the falls. Today a gated retirement community surrounds these falls, but the public can still view them. (AC.)

18

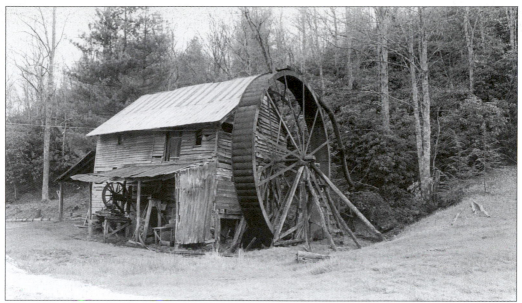

MORGAN'S MILL. James Madison Morgan Sr. left Brevard for Texas, where he made money blacksmithing and training horses as well as fighting in the Texas War for Independence from Mexico. He returned to Transylvania County about 1857 and bought land on Peter Weaver Creek in the Cherryfield area outside Brevard. He built a water-powered grist mill first and then installed a larger water wheel in about 1866. The mill wheel came from the Breese Mill in Mill Cove. Morgan's Mill collapsed in 1999. (HPC.)

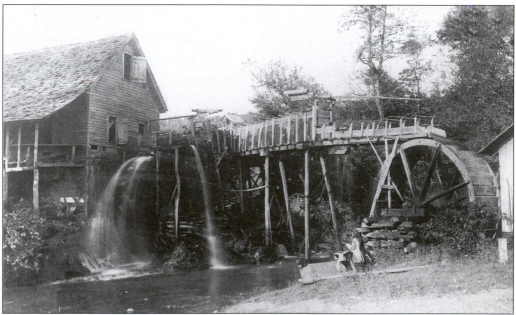

KING'S MILL. Water-driven mills for grinding corn and wheat were a crucial part of the rural economy in the 19th and early 20th centuries. King's Mill was built in about 1830 by Jonathan King. It later had a grist mill on the left and a furniture-making business on the right. The mill was washed away in the great flood of 1916, the same night as its owner, Samuel King, passed away not knowing his mill had been lost. (AC.)

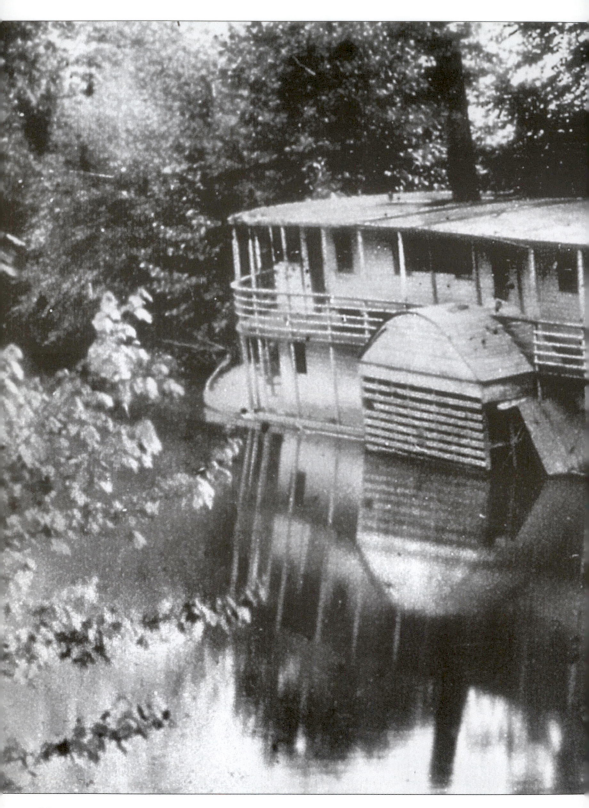

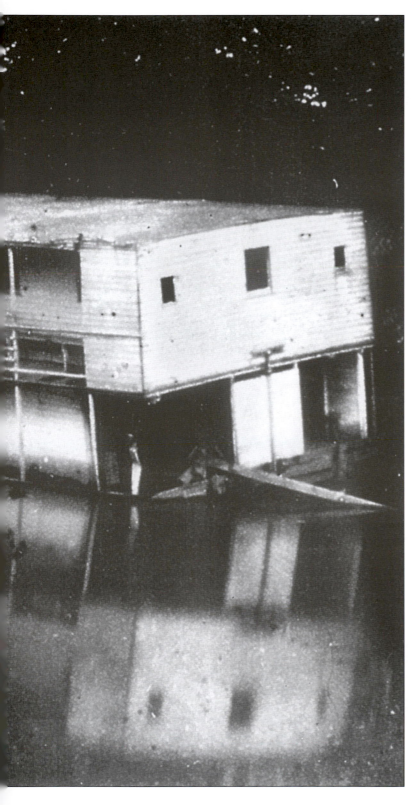

MOUNTAIN LILY. The French Broad Steamboat Company was formed by Col. S.V. Pickens of Hendersonville in 1881. Pickens dreamed of making the French Broad River a navigable stream that could be important for commerce. The Army Corps of Engineers undertook to dig out the channel and blast shoals. Pickens advertised his French Broad Steamboat Company as the "highest steamboat line in the world." The steamboat, christened the *Mountain Lily* (nicknamed "water lily,") was launched with great fanfare on August 2, 1881. Brevard declared a holiday so that everyone could turn out to watch. Alas, the *Lily's* maiden voyage was also her last. A huge rainstorm turned the quiet river into a raging flood and the boat foundered on a sandbank. The hoped-for commercial success of the steamboat line was never realized. (HPC.)

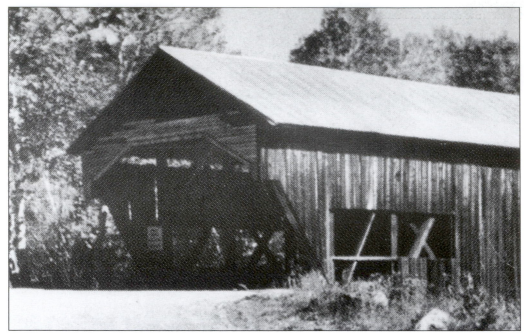

SHUFORD BRIDGE C. 1880. Transylvania County had its own covered bridge, which was located in the Little River area. (MJM.)

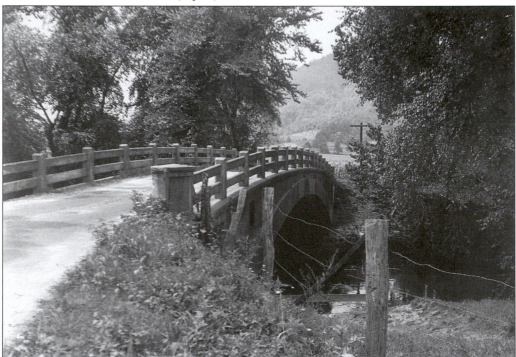

PENROSE BRIDGE. This exquisite curved bridge was located in the Penrose community near the railroad tracks. The Penrose Rock Quarry is just visible in the background. The bridge no longer exists, but the picture pays tribute to the poet-builders of the county who made stone and lumber sing. (AC.)

Two
BREVARD BLOSSOMS
Industry Arrives

The arrival of the railroad in Brevard in 1894, then in Rosman (called Toxaway at that point) in 1900, and in Lake Toxaway in 1903, made it possible for major industry to develop. Logs could now be transported from the forest to the sawmills and then to customers in other parts of the country. Joseph Simpson Silversteen, who had owned a tannery in Pennsylvania, moved to Transylvania County at the turn of the century. He founded Gloucester Lumber Company, Toxaway Tanning Company, and the Rosman Tanning Extract Company as well as the Transylvania Tanning Company in Brevard. He was soon followed in the lumber business by Louis Carr who founded Carr Lumber Company in Pisgah Forest. Carl Moltz founded a third lumber company in Lake Toxaway. While the industry brought prosperity to the county, it was extremely costly to the environment. The forests were clear-cut, denuding the mountains and causing dangerous erosion and floods.

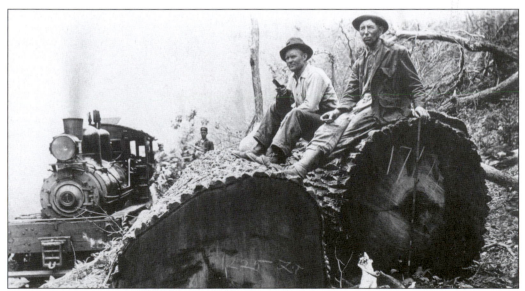

TROPHY LOGS. Jason McCall (left) and Clay Henderson sit atop two of the largest logs brought in by Silversteen's Gloucester Lumber Company; Shay Engine #5 can be seen in the background with its fireman Welch Galloway (left, background) and its engineer Jess Galloway. (WILDE.)

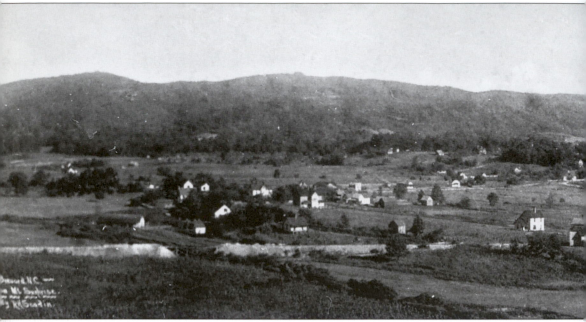

BREVARD'S GOLD MINE. Nicknamed "Mt. Surprise" and known by locals as "Cooper's Hill," the hill is located near the entrance to what is now Millbrook Estates. Local residents remember being told that there was an Indian Cave in the mountain before it became a gold mine. Pat

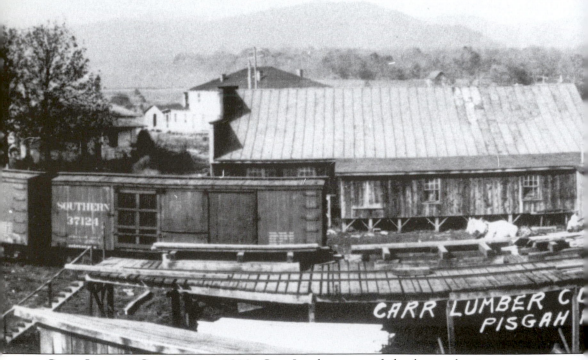

CARR LUMBER COMPANY IN 1910. Carr Lumber, one of the largest logging companies in the United States, was founded by Louis Carr, nicknamed "Calouie" (derived from "Uncle Louie.") He had been an Italian street vendor in New York prior to coming to Brevard to

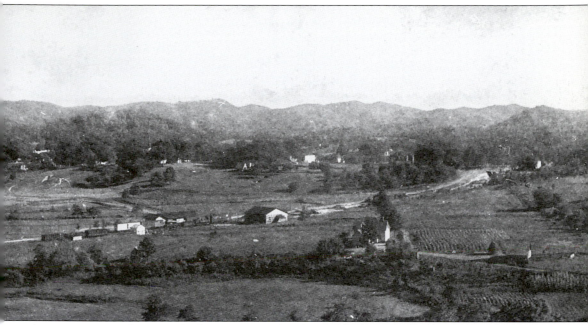

Austin went into the mine shaft as a young girl and says it looks as if it had been excavated into rock. There were two gold mines on Forge Mountain (the other side of Little Mountain a few miles beyond Brevard on the Asheville Highway). (HPC.)

found his lumber company. By 1912, he owned the timber rights to the whole of Pisgah Forest and maintained the rights until the early 1930s. He also had a logging company in New Mexico. (HPC.)

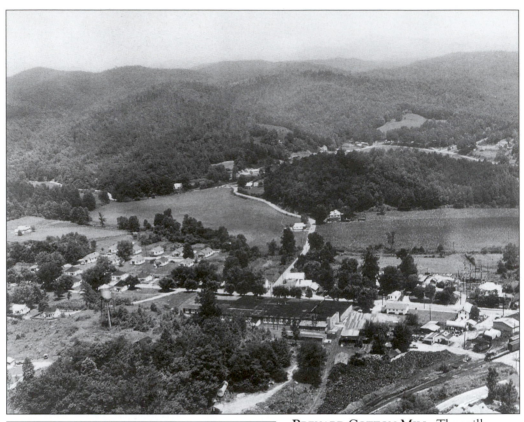

BREVARD COTTON MILL. The mill was also known as Transylvania Cotton Mill, Sapphire Cotton Mill, and Pisgah Mills. This aerial photograph was taken by William Austin in the 1930s. Cooper's Hill can be seen in the background and McLean Road runs through the center. (AC.)

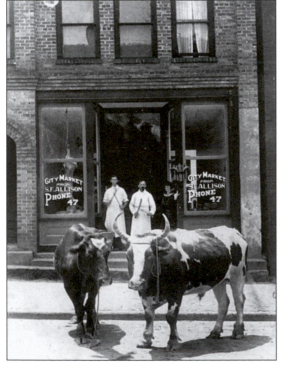

SHARPENING THE KNIVES. Brevard City Market was located on West Main Street in downtown Brevard in the early 20th century. The market belonged to Samuel F. Allison. (HPC.)

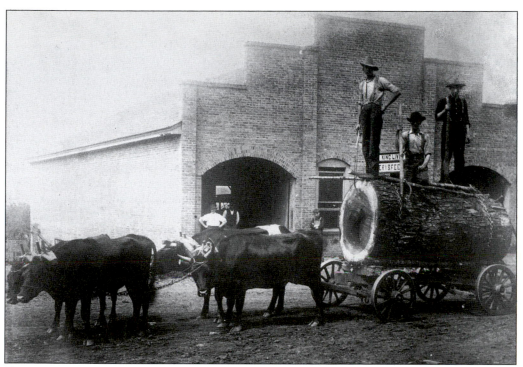

TEAM OF OXEN HAULING LOGS. This team of oxen near King Livery in Brevard may have been delivering logs to Holden's Sawmill, near the railroad tracks. (HPC.)

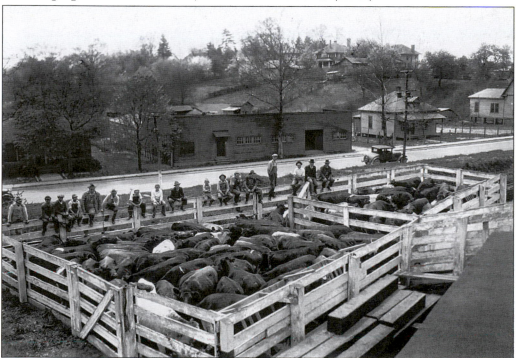

STOCKYARD BY BREVARD DEPOT. The stockyard was located on Railroad Avenue between King and Probart Streets. The Holden Sawmill building can be seen in the background. (AC.)

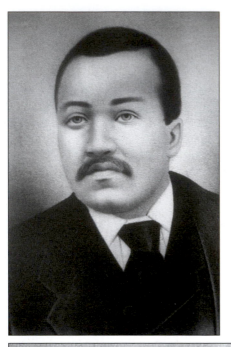

JAMES P. AIKEN. Aiken, the son of a former slave, Jane Aiken Hall, was a successful businessman and a valued asset to the community of Brevard. He owned a barbershop for white men, a feed store, a café frequented by people from all over the county, and a dray service that brought mail from the depot to the post office. In addition, he was a dedicated member of the fire department, the only African-American fireman at that time. He died in 1909 when a two-wheeled fire extinguisher overturned and exploded. The entire business community closed down for his funeral. James Aiken was also the father of world famous comedienne Moms Mabley. (AC.)

AIKEN'S STORE. James Aiken's store was located in downtown Brevard along with his café and barbershop. (AC.)

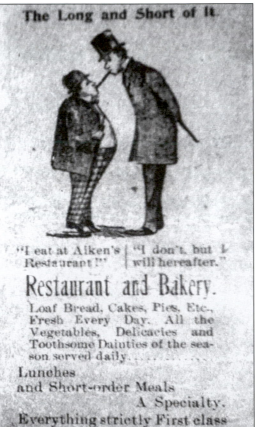

DRAYING.

(Licensed Drayman.)

Special attention given to Drummers' and Tourists' Baggage. Trunks delivered to order in Town or Country.

Drays Meet all Trains.

☞ Prompt service at Reasonable Prices.

J. P. AIKEN, Brevard, N. C.

UP-TO-DATE
BARBER SHOP.

20 YEARS' EXPERIENCE.

An Easy Shave Guaranteed.

Fashionable
 Hair-cutting,
 Shampooing,
 and
 Hair-dyeing
 Carefully Executed.

☞ Razor Honing a Specialty. ☜

The Long and Short of It

"I eat at Aiken's Restaurant!" | "I don't, but I will hereafter."

Restaurant and Bakery.

Loaf Bread, Cakes, Pies, Etc., Fresh Every Day. All the Vegetables, Delicacies and Toothsome Dainties of the season served daily.

Lunches
and Short-order Meals
 A Specialty.

Everything strictly First class
 CALL EARLY AND OFTEN.

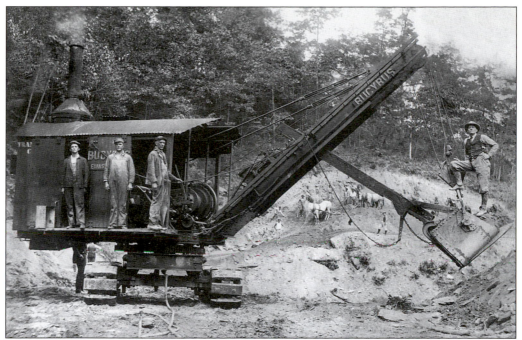

ROAD CONSTRUCTION, 1920s. A steam shovel digs the roadbed in Transylvania County in the late 1920s. (WILDE.)

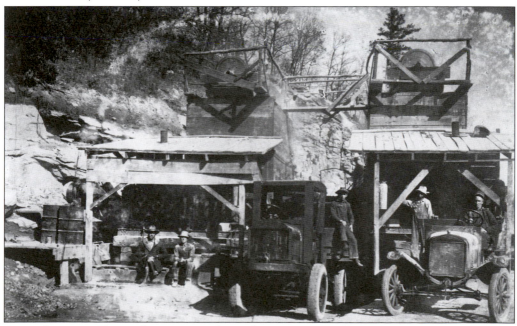

ROCK QUARRY. This rock quarry was located in Rosman. William Benjamin Franklin "Doc" Wright, James Robert Wright, and Joseph Few "Joe" Wright were famous stone masons in the area who moved to Brevard from Hendersonville in 1919. They built spectacular homes, churches, and schools in Brevard and throughout the county. A well-known African-American stonemason named Fred Mills, who had only one arm, learned the trade from the Wright brothers. (WILDE.)

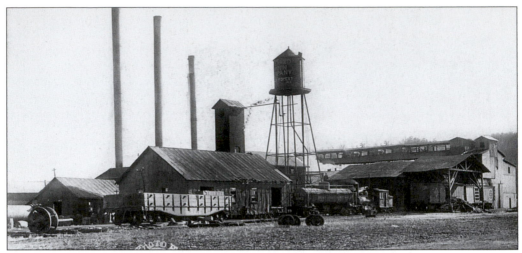

BREVARD TANNIN COMPANY. Brevard Tannin Company was located in Pisgah Forest and was owned by J. Francis Hayes, an executive with the Lake Toxaway Company. The tannin industry was closely tied to the logging industry. Tannin was extracted from the bark of trees being logged in the area and used to turn animal skins into leather. (MJM.)

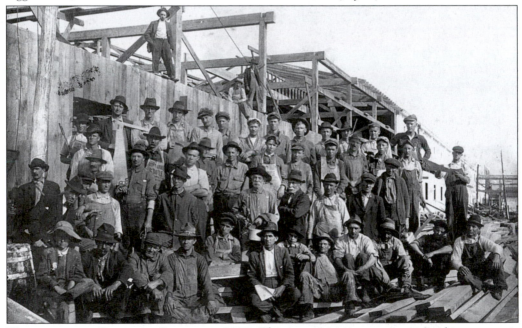

TRANSYLVANIA TANNING COMPANY, 1918. This reconstruction crew was working to repair the plant after a fire. Transylvania Tanning Company opened in Brevard in 1918 and was owned and operated by Joseph Silversteen. One of the huge chimneys still survives on Cashiers Valley Road. The tannery dumped foul waste into the creek (called Nicholson, Brushy, or Tannery Creek), and the employees' café in the midst of the stink of rotting hides was called "The Green Fly." A primary source for tanning was the chestnut tree and the tanning industry was severely affected by the chestnut tree blight in the early 1920s. However, they began to import the bark of the Quebracho tree from Colombia, South America. The tannin was extracted from this bark rather than from the chestnut, which enabled this tannery to remain in business until 1960. (HPC.)

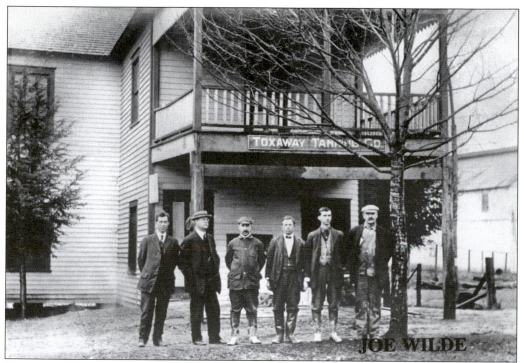

TOXAWAY TANNING COMPANY. Joseph Silversteen started this tanning business in what was then Toxaway in 1902. He renamed the town Rosman, a combination of the names of two business associates Rosenthal and Osmansky. From left to right are two unidentified, Silversteen, Alfred White (former superintendent of the company and a mayor of Rosman), Jordan Whitmire, and unidentified. Silversteen also founded Gloucester Lumber Company and the Rosman Tanning Extract Company. (WILDE.)

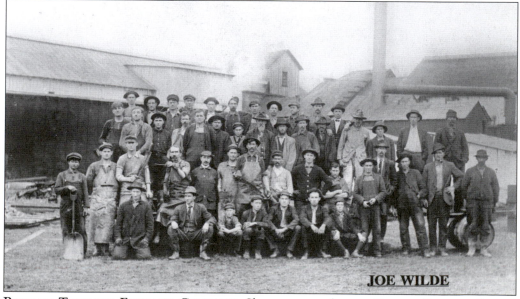

ROSMAN TANNING EXTRACT COMPANY. Shown are workers at Rosman Tanning Extract Company, owned by Joseph Silversteen. (WILDE.)

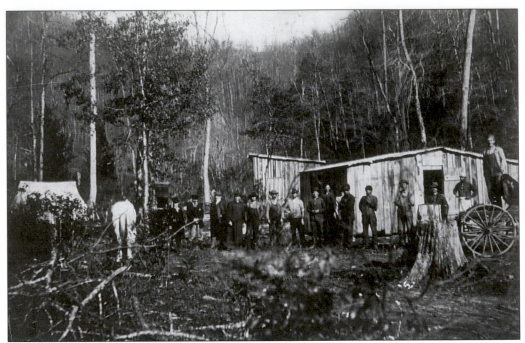

LOGGING CAMP . Logging camp crews and their families lived in small wooden shacks. The tiny shacks were lifted by cranes and loaded onto logging trains as the loggers moved from one location to the next. Before the first of his nine children reached school age, Joseph Wilde took his wife and children from camp to camp while he recorded the logging industry with his photographs. The upper photo was taken on Cathey's Creek in 1908 (MJM); the lower photo was taken by Joe Wilde at John's Rock. (WILDE.)

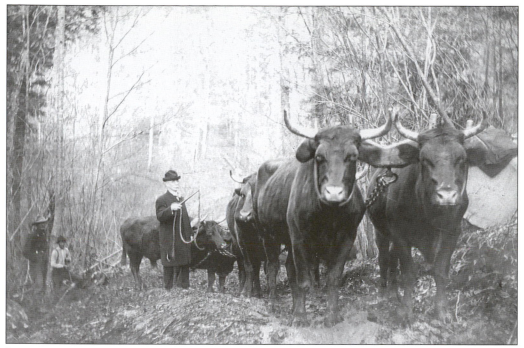

LOGGING UP CATHEY'S CREEK IN 1908. The driver of this team of oxen was Mr. Morse from New York State. This area, with its beauty and its industry, has always attracted people from other parts of the United States. (MJM.)

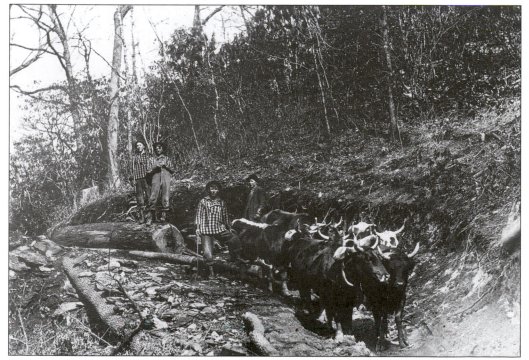

LOGGING TEAM WITH OXEN. Teams of oxen as well as horses were used to snake the huge logs from the forest to be loaded on the train. (MJM.)

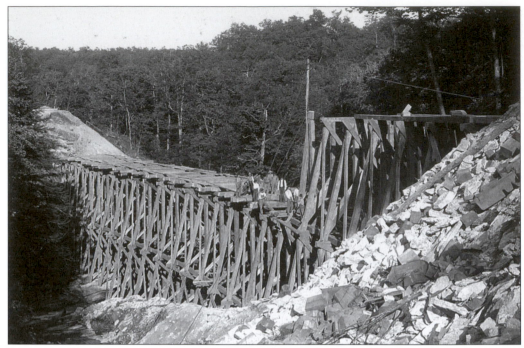

RAILROAD TRESTLE UNDER CONSTRUCTION. This trestle was built early in the 20th century. The mountains presented unique engineering challenges for railroad engineers and building crews. (MJM.)

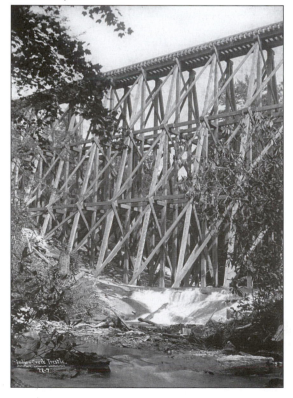

INDIAN CREEK TRESTLE. This towering trestle was near Lake Toxaway. These railroad bridges had to support the huge Shay engines with their heavy loads of logs. When wrecks occurred (as on Bent Field Trestle in 1928, see page 39), the consequences could be serious. (HPC.)

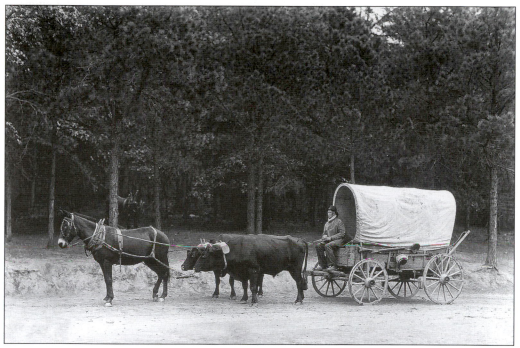

VANCE GALLOWAY WITH RAILROAD SPIKE TEAM, 1927. This was a team that drove the spikes for the railroad tracks. The wagon carried the iron spikes, which were hand-driven to anchor the crossties supporting the tracks. (MJM.)

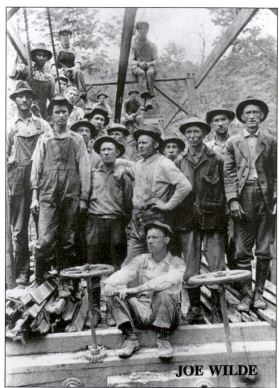

FLATCAR. Wiley Smith, who worked for Gloucester Lumber Company, sits in front on a railroad flatcar. On either side of him are the brakes that could be turned to help slow the train. (WILDE.)

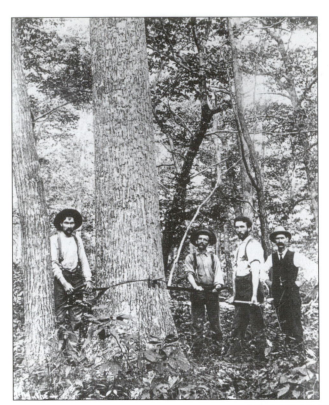

FELLING A TREE WITH A TWO-MAN SAW. A story told of the man on the left is that he was known all over the county for viciously abusing his horses. When he lay on his deathbed, he could hear the horses crying out and he kept calling, "Don't let them horses come after me." (WILDE.)

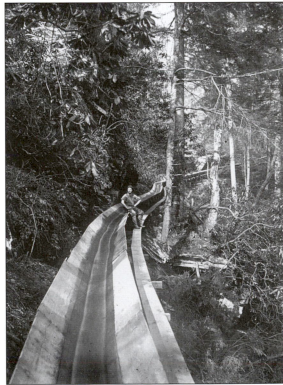

LOGGING FLUME IN CATHEY'S CREEK. Mr. Henry Grogan posed on this logging flume in 1908. The flume was one of the techniques for transporting the logs from the mountainside to be loaded on the train. (MJM.)

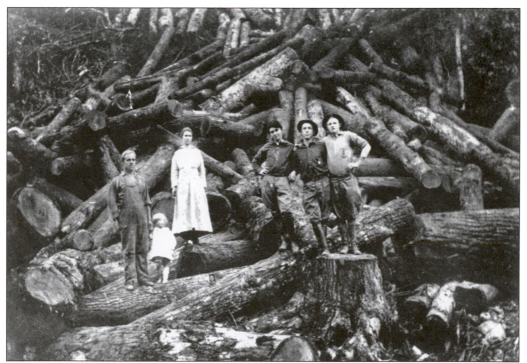

BALL HOOTIN'. This was the slang expression used for tumbling the logs down the mountain. It must have taken courage to pose at the foot of the pile. (WILDE.)

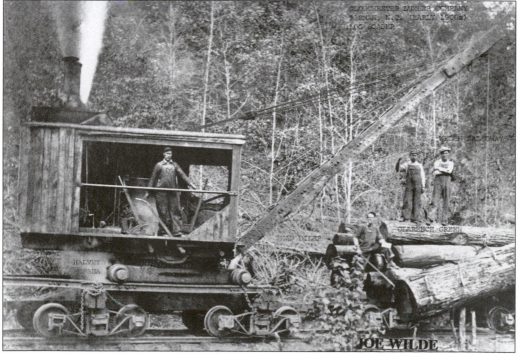

LOG LOADER #4. This photograph was taken in Gloucester in 1924. After the logs had been brought down the mountain, the log loader lifted them onto the flatcars. (WILDE.)

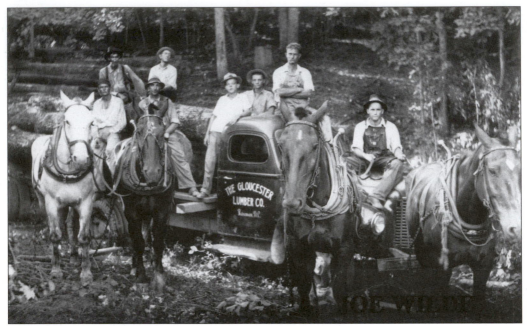

THE OLD AND THE NEW. A working team of horses still carries loads of logs for Gloucester Lumber in spite of the presence of a truck. (WILDE.)

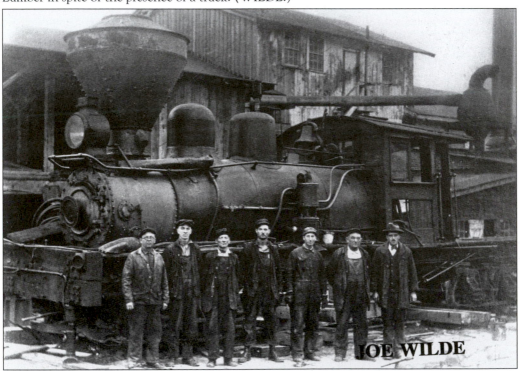

MOLTZ LUMBER COMPANY, 1926. The big Shay engines could pull 60 to 80 tons of freight. Carl Moltz ran his lumber company from Lake Toxaway. The engine was backed into Cold Mountain each morning and came forward fully loaded in the evening. Grant Bruner, second from right, was the engineer of this train. Owner Carl Moltz is at the far right. (WILDE.)

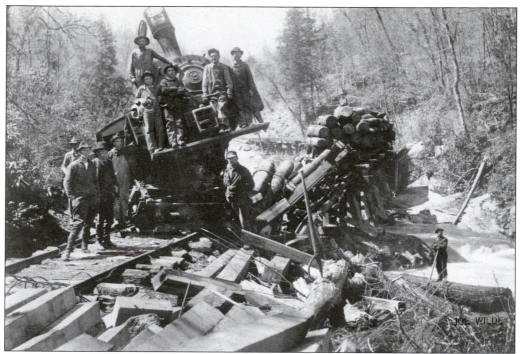

BENT FIELD TRESTLE WRECK IN 1928. The story is that a woman with a sick baby was riding to Rosman on this train. As the train wrecked, a crew member named Hartman grabbed them and jumped to safety. (WILDE.)

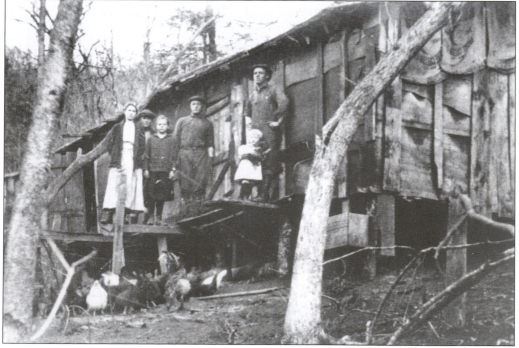

CARR LUMBER COMPANY, 1916. This was housing for Carr Lumber's workers in Pisgah Forest. (WILDE.)

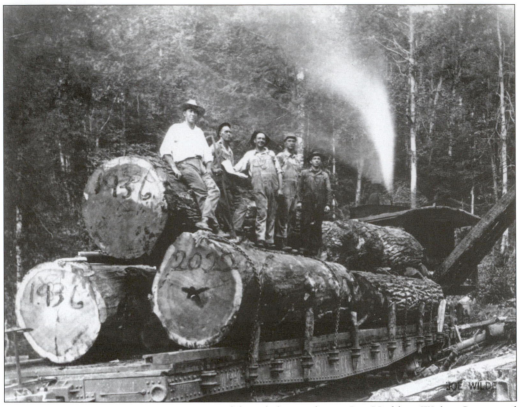

CARR LUMBER COMPANY, 1925. Pictured from left to right are Jim Hedden, Walter Scott, and Ed London. The numbers on the logs represent the number of board feet in each. (WILDE.)

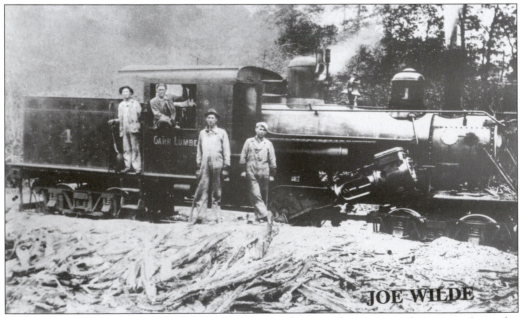

CARR LUMBER COMPANY TRAIN. This photograph was taken in Pisgah Forest where the lumber company was based. (WILDE.)

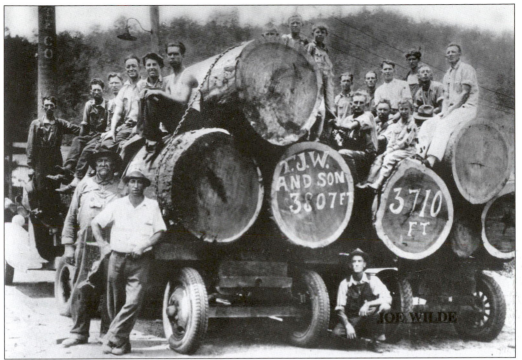

SPECIAL DELIVERY, 1937. This load of logs was delivered to Gloucester Lumber Company by "Big" Tom Wood, standing in the foreground with his son, Rufus Wood. The yard crew poses on top of the load. (WILDE.)

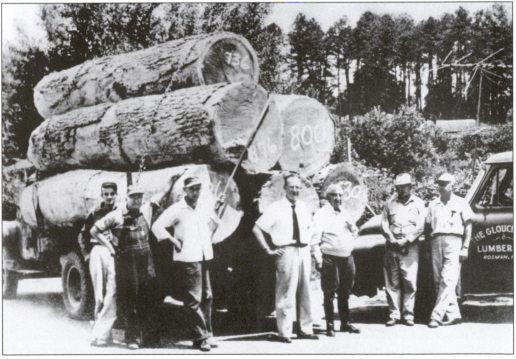

GLOUCESTER LUMBER COMPANY. Joseph Silversteen is fifth from left. (WILDE.)

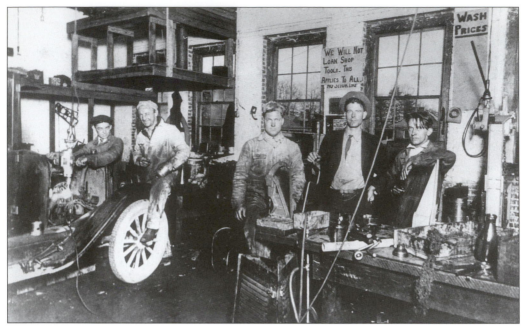

MCLEAN'S AUTO REPAIR IN BREVARD. The men to the left are repairing an old Dodge in the 1920s. This shop was located on the corner of North Broad Street and McLean Road. They do **not** loan shop tools, but they will wash your car. The owner of the shop, John McLean, was the son of Brevard dentist John McLean, whose grandfather received 40 acres of land from the federal government in exchange for leading the Cherokee to Oklahoma on the forced removal known as the Trail of Tears. John McLean's machine shop and Dr. John McLean's house were on this land, which extended back to the railroad tracks and over to the present locations of Brevard College and First United Methodist Church. (HPC.)

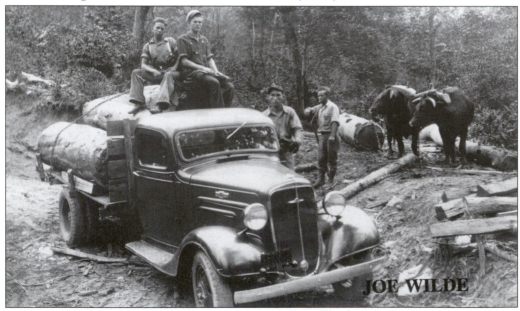

LOGGERS IN LAKE TOXAWAY. Albert Lee and Edward Johnson pose on their loaded pick-up truck, with a team of oxen in the background. (WILDE.)

Three
LAND OF WATERFALLS
Tourism Flourishes

Even before the Civil War, wealthy families from South Carolina, Georgia, and Louisiana had traveled to the area of Brevard to escape the summer heat and humidity, as well as the threat of malaria. After the war, economic pressures made this impossible for many people. But with the coming of the railroad in 1894, it became possible for people from all over the country to visit the area. In 1895, J. Frances Hayes, who had moved to Western North Carolina from Pennsylvania for his health, formed the Toxaway Company. Many of the stockholders lived in Pennsylvania. Hayes also built the $25,000 Franklin Hotel in Brevard in exchange for the city's support of a bond issue for the extension of the railroad to Toxaway (soon to be Rosman) in 1900. In 1902, the Toxaway Company constructed a 60-foot-high dam on the Toxaway River, creating a lake three miles long and a mile wide. The lake and the Toxaway Inn were completed in 1903. On August 13, 1916, due to a congruence of hurricanes that produced disastrous flooding, the dam broke and the entire lake emptied out. The dam was rebuilt in 1961.

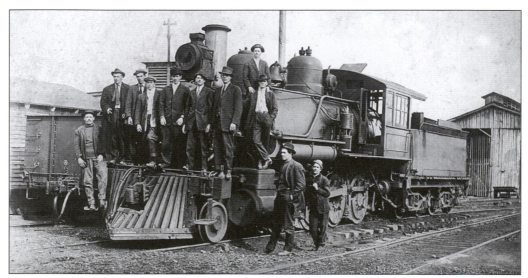

THE RAILROAD COMES TO BREVARD. This Baldwin Road Engine pulled passenger trains between Hendersonville and Brevard in the early 1900s. Frances Hayes of Toxaway Company bought the Brevard-Hendersonville Railroad. When the railroad came, hotels, inns, and boarding houses began to proliferate. (Joe Paxton Collection in HPC.)

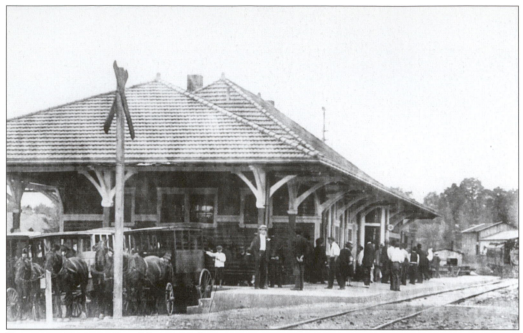

BREVARD DEPOT. In addition to bringing tourists to the town in increasing numbers, rail service also meant that lumber mills could begin operation. This furnished the first major employment other than farming. Local folks still remember a tragic death at the depot around the turn of the century. A beloved local boy named Van Breese slipped on a pile of cinders while trying to hand a letter into the mail car as the train pulled away from the station. He was pulled under the train and lost both legs. He died just as his rescuers reached the hospital. He was 18 years old. (AC.)

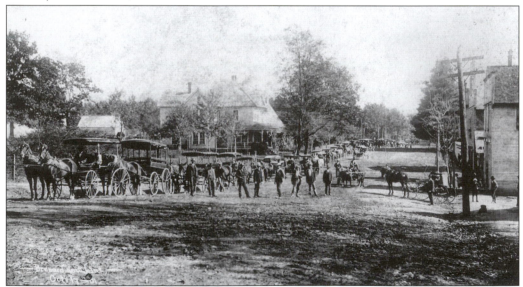

HACKS WAITING FOR TOURISTS. Horse-drawn cabs typically parked near the Brevard train station waiting to transport tourists to hotels and boarding houses. These were parked on East Main Street. This photo was taken on October 17, 1901, looking east from the courthouse. (HPC.)

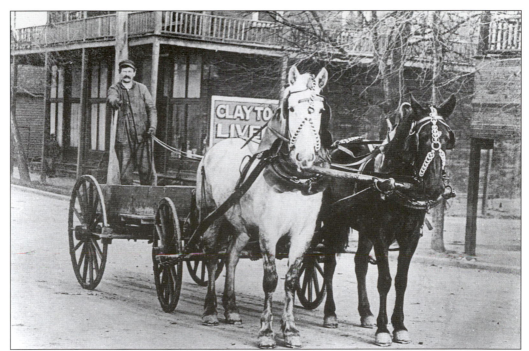

CLAYTON LIVERY. The Claytons owned a livery service (visible in background) behind the Clayton Hotel. This driver (who did not work for Clayton Livery) is Howard Hedrick, with Barney (the white horse) and Ham. He owned Hedrick's Grocery in Pisgah Forest. (HPC.)

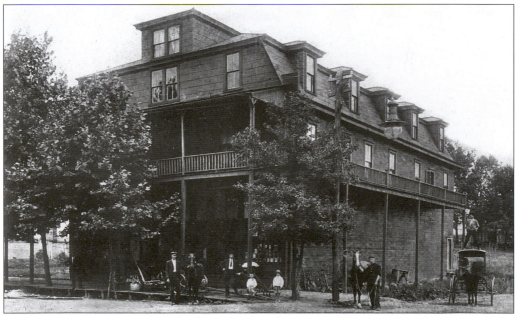

CLAYTON HOUSE (HOTEL). Built about 1895 on the corner of Main and Caldwell Streets, the home was owned by Joe and Belle Clayton, who operated it as a hotel. It had a lobby, dining room, kitchen, and general store on the first floor. Family living quarters and rooms for guests were on second and third floors. Clayton House was nicknamed "the tin hotel" because its siding was tin. (AC.)

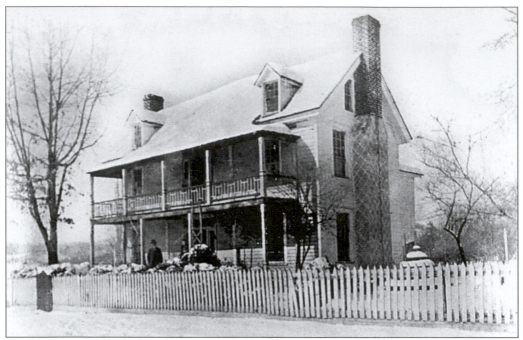

HENNING INN. Built in the late 1800s, the inn was located at the northwest corner of Jordan and England Streets. Another home owned by the Henning family on West Main Street was the first location for the Epworth School begun by Mr. and Mrs. Fitch Taylor. When the school enrollment grew too large, they moved it to The Red House on Probart Street. (HPC.)

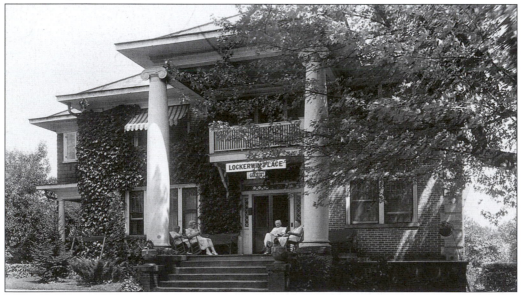

BOARDING HOUSE. Lockerwin Place was originally the DeVane House, later the Erwin House, and was then purchased by the Austin family. The home is now Moody Connolly Funeral Home on Caldwell Street. Lockerwin Place was one of many boarding houses in Brevard. Taking in boarders was a good way for folks to make much-needed extra money. Rates listed in 1907 averaged $7 to $10 per week. There were as many as 30 boarding houses in Transylvania County in the 1930s. (AC.)

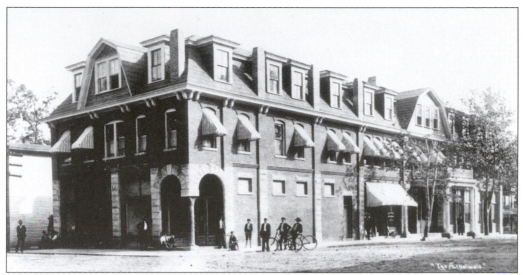

AETHELWOLD HOTEL. This hotel opposite the Transylvania County Courthouse was built in 1902 by John William McMinn. He operated the hotel, which he had named for his wife Ethel, until his death in 1918. The hotel was then sold to T.W. Whitmire, who changed its name to the Waltermire Hotel after his son. Robert T. Kilpatrick, who built many of the buildings in downtown Brevard, was in charge of construction. This photograph may have been taken by E.C. Glover, who had a studio in Brevard for a couple of years just after the turn of the 19th century. The building still houses a variety of businesses on East Main Street. (AC.)

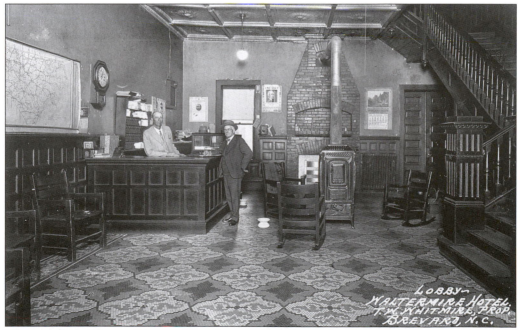

WALTERMIRE HOTEL LOBBY. The former Aethelwold Hotel was the scene of a still-remembered practical joke. Jack Hudson's grandfather, while attending an *eatin' meetin'* at the hotel, prearranged with a waiter to insult him. Hudson's grandfather then pulled out a gun and "shot" the waiter, who was prepared with catsup and staged a dramatic fall to the floor. The friends for whom the joke was staged were appropriately shocked. (HPC.)

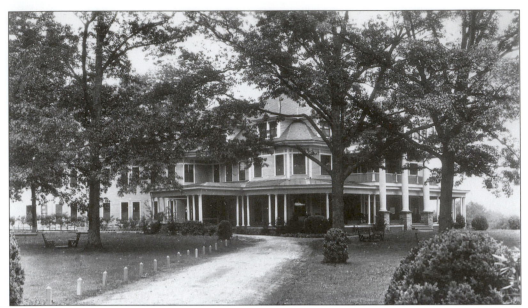

FRANKLIN HOTEL IN 1927. The luxurious Franklin Hotel, which opened on July 4, 1900, was built by J.F. Hayes of the Toxaway Company. The hotel was set in an 80-acre park with a lake. Every room had a view of the grounds. Brevard's Franklin Park and pool now occupy a portion of that land. The Franklin Hotel was known as one of the finest in the South and remained in operation until the early 1950s, when it was torn down to make room for Brevard-Davidson River Presbyterian Church. In fine weather, people gathered outside and on the porches for tea and entertainment. (AC.)

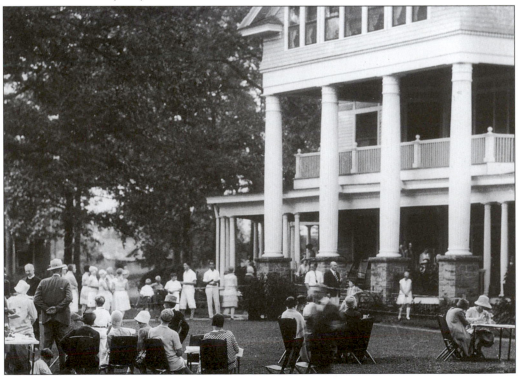

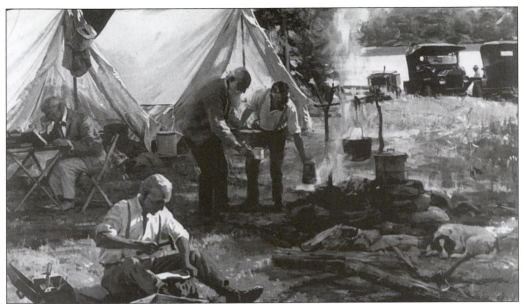

HENRY FORD CAMPING WITH FRIENDS. In this photo of a painting from about 1914, Henry Ford, Thomas Edison, John Burroughs, and Harvey Firestone are seen camping near Lake Toxaway. The four also went on a well-documented camping tour through the Appalachian Mountains in 1918, but the closest they came to Brevard on that trip was the Grove Park Inn in Asheville. However, Ford had stayed at the Toxaway Inn, and the four friends often visited the Bacchus Lodge on Cold Mountain Road, which belonged to a Chicago industrialist. They often camped at Cold Mountain near Lake Toxaway (a different Cold Mountain from the one near Wagon Road Gap where Charles Frazier's novel is set). (HPC.)

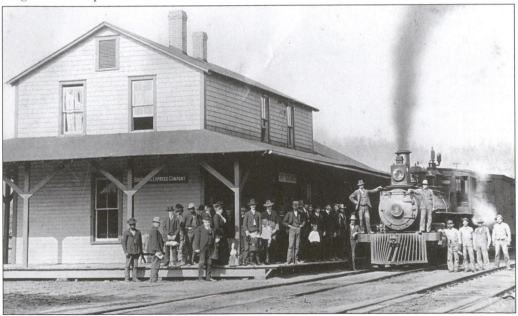

PASSENGER ENGINE AT ROSMAN STATION, 1903. These passengers are ready to board the train. The railroad was extended from Rosman to Lake Toxaway in 1903. From two to six Pullman passenger trains ran daily to Lake Toxaway until the lake was destroyed in 1916. (HPC.)

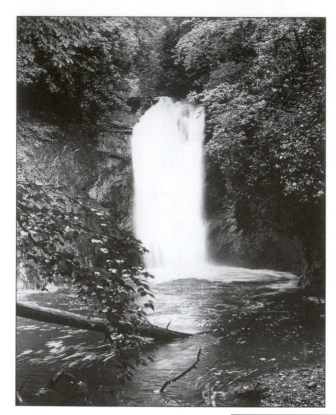

COURTHOUSE FALLS. Courthouse Falls is the birthplace of the French Broad River, which rises under Devil's Courthouse on the Blue Ridge Parkway. This exquisite spot, a little grotto filled with rhododendron and mountain laurel, is about 20 minutes from Brevard. Courthouse Falls is one of over 250 named waterfalls in the county. Brevard was known, from the earliest tourism brochures, as "the land of waterfalls." The area was once nicknamed "Cascadia." (Courtesy of the Jim Bob Tinsley Museum.)

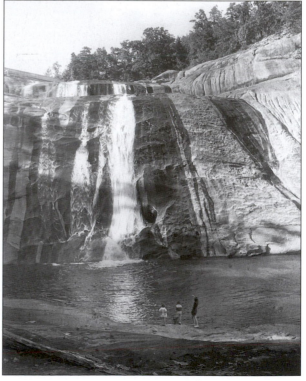

TOXAWAY FALLS. The falls continued to draw tourists after the dam broke. The movie *Thunder Road,* starring Robert Mitchum, was filmed here. It told the story of Kentucky moonshiners pursued by revenuers. For one scene in the movie, the crew rolled a junk car over the falls. One Brevard resident remembers seeing Mitchum drunk during filming takes. (AC.)

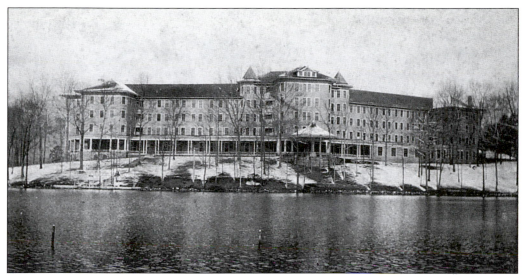

TOXAWAY INN. The inn was built by J. Frances Hayes from Newcastle, Pennsylvania, who founded the Toxaway Company in 1896 and dammed the Toxaway River to form Lake Toxaway. The Toxaway Inn opened in March 1903. Hayes also built the Franklin Hotel in Brevard and was president of the Brevard Banking Company. After the dam broke in 1916, the inn was forced to close and was eventually torn down. (MJM.)

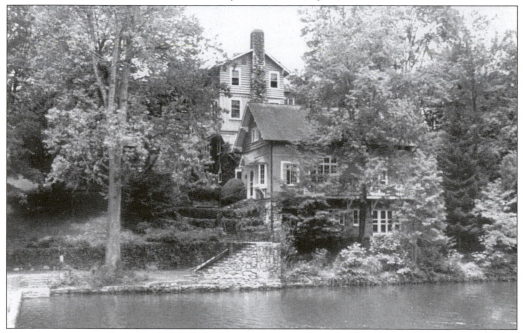

THE GREYSTONE INN. In 1912, Lucy Armstrong purchased 40 acres at Lake Toxaway and "camped" there in a tent with a wooden floor. She began building a Swiss chalet-style house, which became a 30-room, 16,000-foot mansion surrounded by the lake on three sides. The home, called Hillmont, was completed in 1915. After her husband's death in 1924, she moved from Savannah to Hillmont in spite of the fact that the lake was gone. She lived there until 1963. The home was restored and in 1985, Hillmont was renamed the Greystone Inn, which today is an elegant resort hotel. (HPC.)

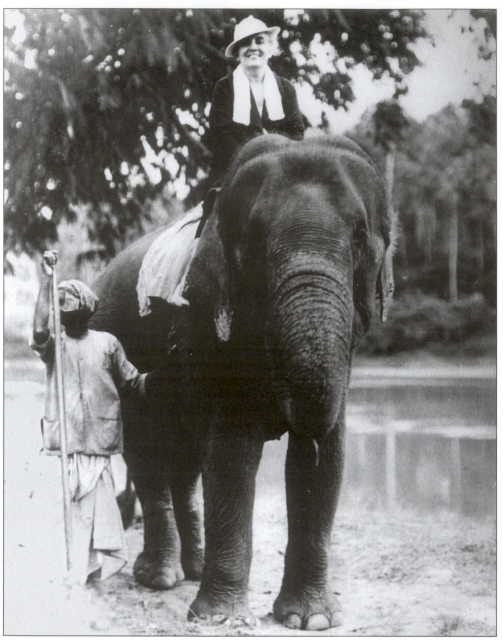

Mrs. Moltz with Elephant. This picture was taken on a trip to India. Lucy Camp Armstrong Moltz, born in Suffolk, Virginia, married George F. Armstrong in 1905. The Armstrongs settled in Savannah, Georgia, where he became a prime developer of the port of Savannah in the early 1900s. Although they built a grand home in Savannah still known as "the Armstrong House," Lucy's first love had become the mountains of Western North Carolina. They had stayed at the Toxaway Inn, where she probably had tea with Henry Ford, Harvey Firestone, Thomas Edison, George Vanderbilt, and many other notable figures of the day. Six years after her husband's death, Lucy married Carl Moltz, owner of the Moltz Lumber Company in the Lake Toxaway area. They were world travelers and brought the flavor of that world back to their beloved mountains. (HPC.)

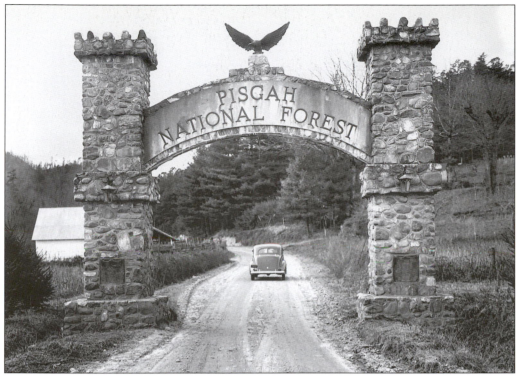

GATES TO PISGAH NATIONAL FOREST.
These spectacular stone gates, a memorial to World War I veterans, welcomed visitors to Pisgah National Forest, which opened to the public in 1936. The national forest was acquired just in time to save a huge area that had been heavily logged for years. Much of the land had been part of the Vanderbilt Estate and was acquired from Vanderbilt's widow in 1917. These gates were eventually torn down and a new granite entrance was built to make the entrance wide enough for modern trucks and camping trailers. The eagle was mounted to one side, but was later stolen. Rumors are plentiful, but no one actually knows its whereabouts. (AC.)

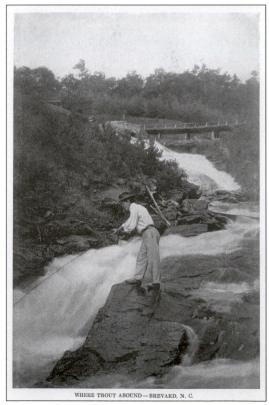

WHERE TROUT ABOUND—BREVARD, N. C.

WHERE TROUT ABOUND. This photograph was part of a tourist guide to Western North Carolina put out by the Southern Railway in 1914. Trout fishing in the streams near Brevard continues to be a popular sport. (Courtesy of Pat Austin.)

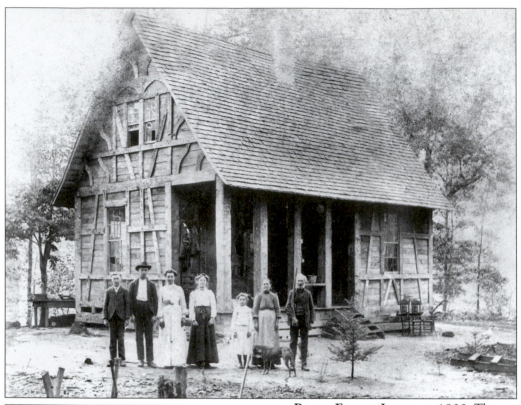

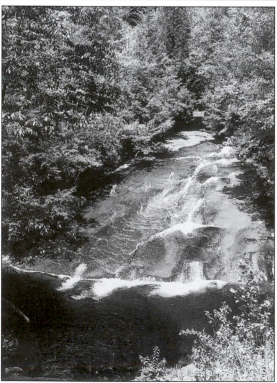

BLACK FOREST LODGE C. 1900. The lodges were faithful copies of Black Forest lodges from Carl Schenck's native Germany. Dr. Schenck from Lindenfels, Germany, succeeded Gifford Pinchot as George Vanderbilt's forester. Schenck established the Biltmore Forest School, the first school of forestry in the United States and now known as the "Cradle of Forestry." The lodges were used as homes for foresters in training. Vanderbilt extended his estate to include an 80,000-acre tract called Pisgah Forest after Mount Pisgah, a prominent peak on what is now the Blue Ridge Parkway. An example of one of the lodges can still be seen at the Cradle of Forestry in the Pink Beds, part of Pisgah National Forest about 20 minutes from Brevard. (AC.)

NATURE'S OWN WATER PARK. Sliding Rock, off U.S. 276 about five miles from Brevard, remains a popular spot for people of all ages to play during the summer. (MJM.)

Four
HARD TIMES
War and Survival

Farming in mountain terrain required hard work and, like the rest of the country, Brevard was profoundly affected by its nation's wars and by the Great Depression. Between 1917, when the United States entered World War I, and 1918, when the war ended, North Carolina sent 86,000 men into the service. As a result of desperate economic conditions in Europe following the war, prices for America's farm and factory goods began to drop. When the stock market crashed in 1929, banks failed, farmers could no longer pay the mortgages on their farms, businesses closed, and people lost their jobs. With the "New Deal" programs beginning in 1933 rural areas began to have access to power and the Civilian Conservation Corps created jobs for young men. During World War II, North Carolina sent 362,000 citizens into the armed services, 7,000 of whom were women.

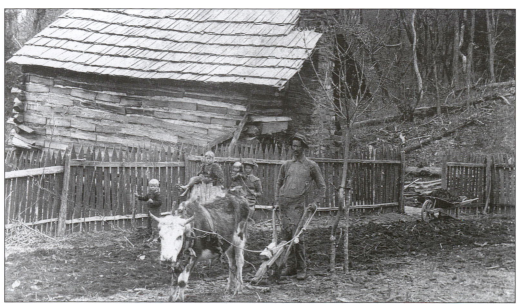

SPRING PLOWING, 1897. The Miller family stand with what appears to be their milk cow, who is skin and bones, pulling the plow. A hen's nest can be seen by the chimney. They are, from left to right, Noah, Lola, Louesa (holding baby Ethel), and David, who is plowing. (Courtesy of R.H. Scadin.)

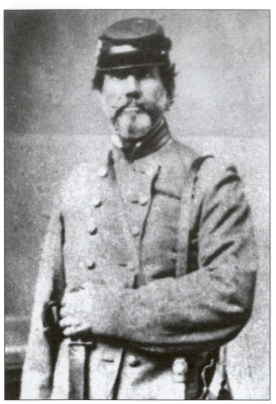

CIVIL WAR VETERAN. Francis Withers Johnstone was elected captain of Company E, 25th N.C. Regiment, in the Confederate Army. His nephew is thought to have been the first person from the county to be killed in the Civil War. Johnstone was one of the seven men elected to the first county court. Johnson Street in Brevard was named for him, though the spelling was later changed. Johnstone gave the land for St. Paul's in the Valley, the first Episcopal church. (MJM.)

CIVIL WAR VETERANS. This first reunion of old soldiers of the Civil War took place in the late 19th century. (MJM.)

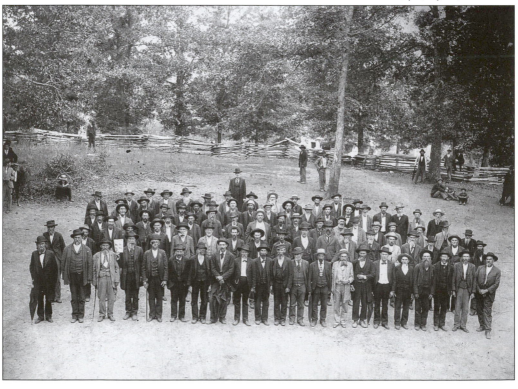

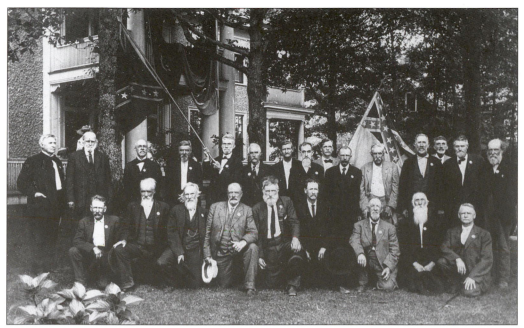

BREVARD'S CIVIL WAR VETERANS IN 1911. From left to right are (front row) unidentified, Lewis Patton Summey, Samuel Lance, Thomas Lenoir Gash [served as clerk of court and mayor of Brevard], George Wilson, unidentified, E.H. Henning, Willie Deaver, E.B. Clayton, and J.M. Hamlin; (back row) Maj. William E. Breese Sr. [joined the Confederate Army at age 16], Ashbury Shuford, unidentified [guest speaker], John S. Allison, Jasper M. Orr, two unidentified, Samuel Ingram, Joseph Kern, Joseph Miller, James Wilson, John Thrash, William A. Johnstone, and H. Clayton Gillespie. The inscription reads "Souvenir of Veterans' Reception sent to Mrs. M. A. Stonewall Jackson in August 1911." Mrs. Jackson, widow of the famous Confederate general, attended the reunion, which was held at the Breese House. (HPC.)

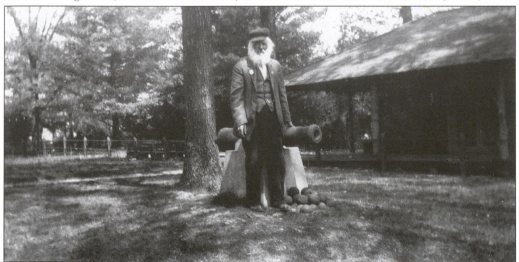

CIVIL WAR VETERAN WITH CANNON. Lewis Patton Summey was a veteran of the Civil War. The photo was taken at the reunion of Civil War Veterans in Brevard in 1911. The cannon, minus the cannon balls, still sits in front of the Transylvania County Courthouse. The United Daughters of the Confederacy Library can be seen on the right. (HPC.)

WORLD WAR I VETERAN IN APRIL, 1919. This photograph was taken of Capt. Charles Emmett Lyday at the University of Lyon in Lyon, France. Captain Lyday served in the United States Army and was a member of one of the founding families of Brevard. (MJM.)

WORLD WAR I. These are Transylvania boys in the first conscription in 1918. Not all names are known and the order is not indicated. In the first row are Virgil Merrill, Avery Orr, Laughton Lyda, and V. Orr. In the second row are Jesse Scruggs and Harold Hardin. In the third row are Ernest Miller, Hal Hart, and R. Surrett. (MJM.)

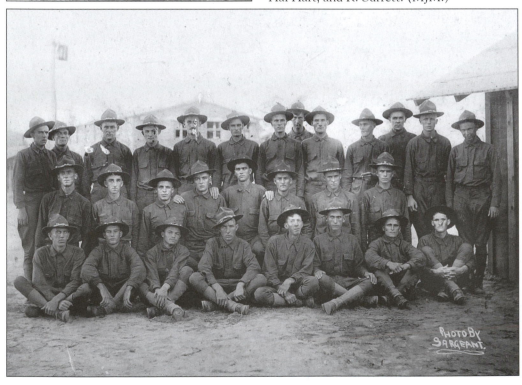

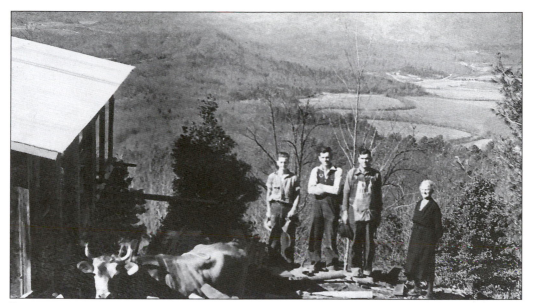

RAISING A HOUSE ON SEE OFF MOUNTAIN. Neighbors Cecil Wilson, Fred Landreth, and Herman Hogsed have come to help build a home for Mrs. Ware, who was the mother of Ann Boatwright. Her old cow stands guard with her back to the spectacular view of Brevard down below. (HPC.)

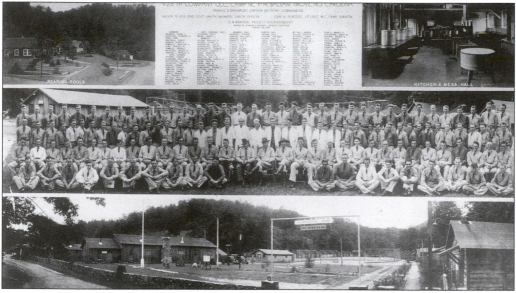

CIVILIAN CONSERVATION CORPS. There were three CCC camps in Transylvania County, including this one in Balsam Grove. The CCC was begun during the Depression to provide work for young men unable to find jobs. The camps carried out huge public works projects, as did another organization called the Works Progress Administration, which had a youth organization called the NYA (National Youth Association.) Young men from this group built the stone wall and gates for Brevard College. The civil engineer who supervised their work was W.A. (Bill) Wilson, father of Dottie Tinsley. These groups were another factor in bringing people to Brevard. Ikey Ayers, a member of the CCC, remained in town and opened Ayers Store, a cherished Brevard institution on West Main Street until the 1980s. (HPC.)

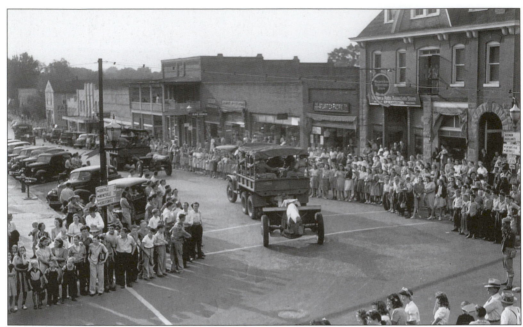

ARMY CONVOY, SEPTEMBER 11, 1941. An army convoy winds its way through downtown Brevard. An artillery group was on maneuvers in Pisgah National Forest. Becky Huggins remembers her cousin putting an army jeep through its paces for the crowd. Less than three months before Pearl Harbor, the date seems even more chilling in the 21st century, when September 11 carries such weight. (AC.)

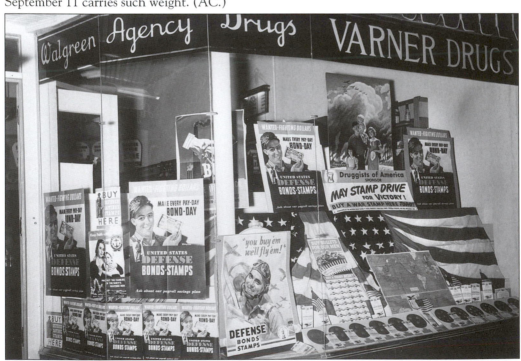

VARNER'S DISPLAY WINDOW DURING WORLD WAR II. Ads for war bonds and patriotic posters decorate the window of Varner's Drugstore on the corner of Broad and Jordan Streets. (AC.)

WARTIME MARRIAGE. Nathaniel Boyce Hall and his lovely Catherine were married on August 1, 1941, in Orange, New Jersey. He was an Air Force quartermaster who served in England and Germany during the war. After the war, the couple moved to Washington, D.C., where Mr. Hall became a history teacher and school principal. Nathaniel Hall is the son of Cleveland and Etta Hall and the brother of Selena Robinson. He has retired to Brevard. (Courtesy of Mr. Nathaniel Hall.)

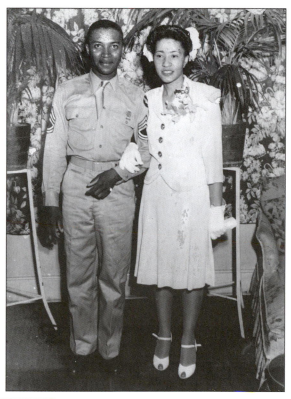

WORLD WAR II CASUALTIES. The three Miller brothers, Fred, John Duckett, and Henry, were all Eagle Scouts and outstanding young men. Fred graduated from West Point, John from the Naval Academy, and Henry joined the Air Force. Fred Miller (left) was shot down in a bombing raid in Europe. His brother John (right) died when his submarine went down in the Sea of Japan. After their deaths, Henry was transferred to safe duty to spare the family further tragedy. (MJM.)

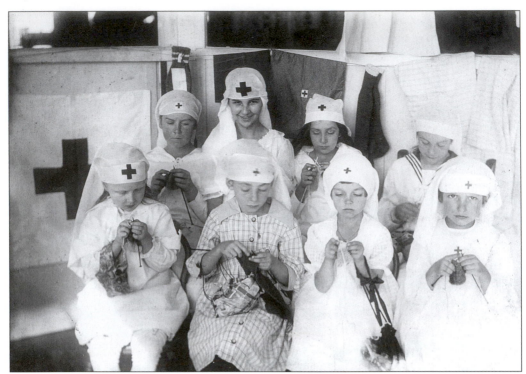

LOCAL GIRLS SUPPORT THE WAR EFFORT. Adelaide Silversteen, Martha Breese Hudson, and their young friends are knitting for the Red Cross. (HPC.)

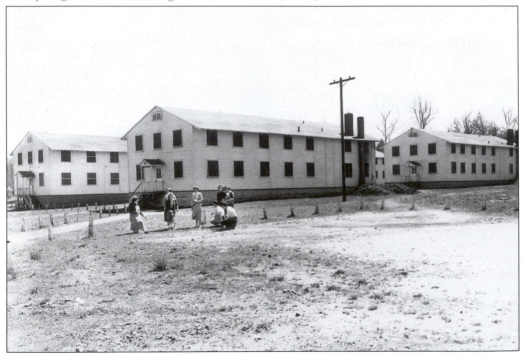

THE G.I. BILL. These barracks were built on the Brevard College Campus for returning veterans under the G.I. Bill after World War II. (AC.)

Five

MOUNTAIN LIVING
Education and Faith

Because of the geography in the area and the lack of good roads, schools were located in the immediate communities from which their pupils came. In the earliest days, they were typically one-room cabins heated by a wood-burning stove. One or two teachers taught all ages and subjects. The first schools were supported by subscription, but by mid-century there were a few schools supported by churches. Public schools may have begun as early as the 1840s, but there were no taxes levied to support them until 1906. Religious life was vital to the early settlers though pastors were in short supply. Churches began forming in the area early in the 19th century. The earliest Baptist church in the county is thought to have been Cathey's Creek Baptist Church, formed in 1800. The earliest Presbyterian church was nearby at Dunn's Rock, and before the Civil War began, an Episcopal church, called St. Paul's in the Valley, was built in that same area by a group of summer residents from Charleston.

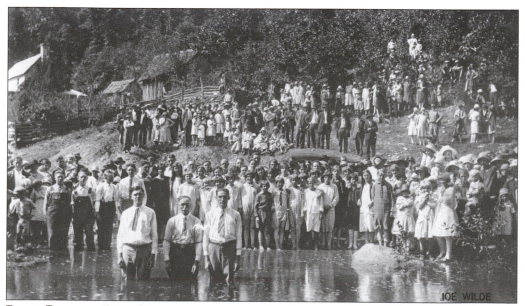

RIVER BAPTISM. River baptism was common among area Baptist and Pentecostal churches. This one took place at Robert Kilpatrick's Place in the Gloucester Community. Pastor Gene Moore stands in the front row at left. (WILDE.)

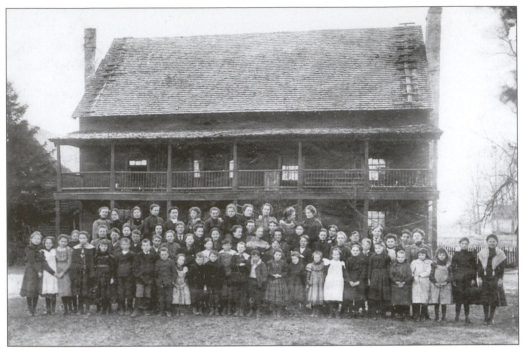

EPWORTH SCHOOL IN THE RED HOUSE. In 1895, the Red House became the location for the Epworth School, founded by Mr. and Mrs. Fitch Taylor. Members of the Epworth School pose in front of the Red House on Probart Street, where the school was located until the turn of the century. It then became the Brevard Institute and moved to the present location of Brevard College on Broad Street. Today, the Red House is a charming bed and breakfast. (HPC.)

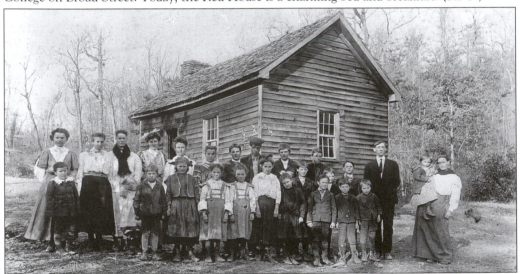

MINE MOUNTAIN SCHOOL. This school was located in Cedar Mountain on Reasonover Road. The teacher was Mark Osborn. Mary Summey is to the right holding Mason Summey. Others, from left to right, are Ollie Summey, Nannie Sue, Eva Garren, Cora Heath, Mac Heath, Lum McCrary, Dorse Allison, Carol Jones, Drexel Brown, France McCrary, Columbus Summey, Sanford McCrary, Estelle Brown, Pearl Summey, Mary Burns, Lucy Burns, Corrie Jones, Markley Jones, and Theodore McCrary. (Courtesy of Vera Jones Stinson.)

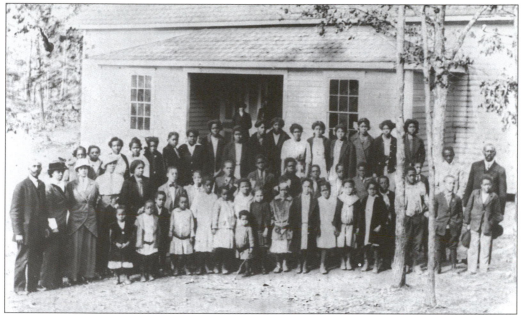

ROSENWALD SCHOOL IN THE EARLY 1920S. Brevard's first school for African-American children was a two-room school on Rice Street. In 1910, this four-room frame building was constructed on Rosenwald Lane. The building burned in 1941 and, for seven years, the children attended classes in local churches where their teachers came to teach them. In 1928, a primary school was built on Rosenwald Lane. It was a well-equipped stone building but only served children through the eighth grade. High school students had to ride a school bus all the way to Hendersonville. They had to leave home at 7 a.m. every day and travel over 20 miles. Brevard's African-American community decided the time had come to insist that their children be allowed to attend Brevard's public schools. Local lawyers would not take the case, but an Asheville lawyer, Reuben Dailey, represented them in court. Brevard High School accepted a few black students in 1962–1963, one of the earliest in the state to do so. By 1966 the school system was completely integrated. (Courtesy Dian Brewton.)

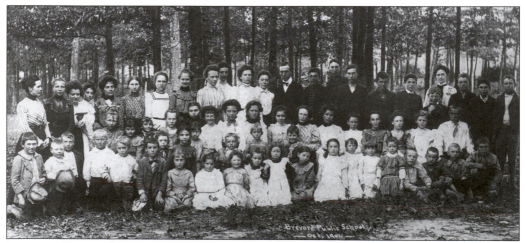

BREVARD PUBLIC SCHOOL, 1901. Many of the county's schools had been subscription schools prior to the 20th century, when public schools became more common. (MJM.)

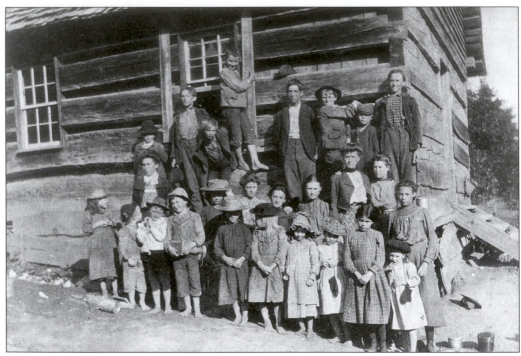

THE QUEBEC LOG SCHOOL. Schoolchildren often came to school barefooted in warm weather. (HPC.)

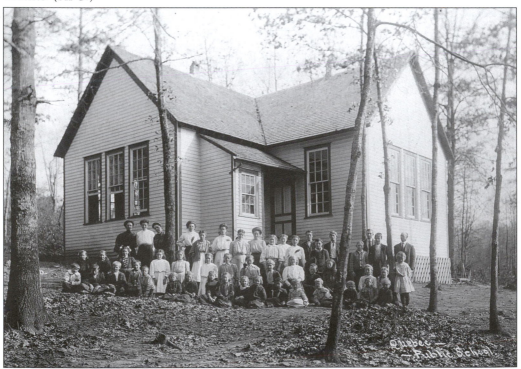

THE QUEBEC SCHOOL IN THE EARLY 1920S. The Quebec School shows obvious improvements after taxes to support local schools were instituted. (HPC.)

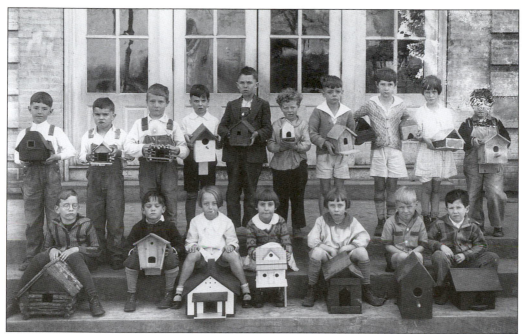

BREVARD ELEMENTARY IN 1928. This is Mrs. Rufty's first grade class at Brevard Elementary School. Bill Austin, the photographer's son, is on the first row to the far left. He remembers that most of the birdhouses (including his) were "professionally made" by the respective dads. Fourth from left is Martha Kate Moore, whose dad was a funeral director and owner of the hardware store next to the Clemson Theater. Her birdhouse boasts two levels. Mary Helen Galloway is to the right of Martha Kate. Jim Bob Tinsley is in the back row at far right. (HPC.)

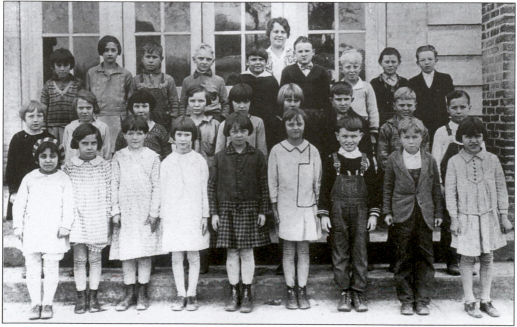

BREVARD ELEMENTARY STUDENTS IN 1928. These children were in Miss Aiken's second grade class. (MJM.)

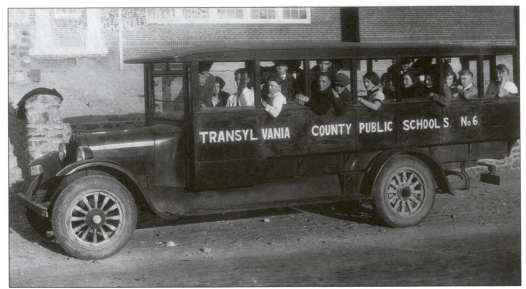

SCHOOL BUS. In about 1926, Transylvania County school bus No. 6 brings students to school in Rosman. School buses in those days were black, not orange. (AC.)

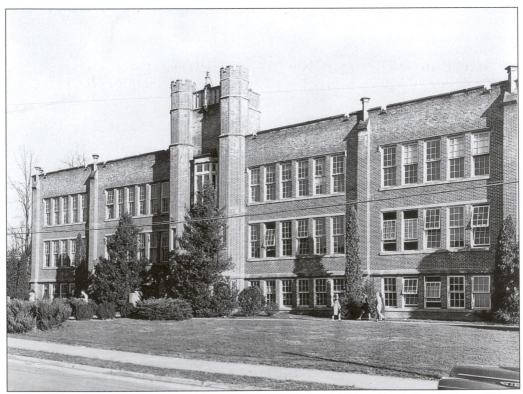

BREVARD HIGH SCHOOL. This building was constructed in 1925 on South Broad Street. There were 27 teachers for a student body of about 125. (AC.)

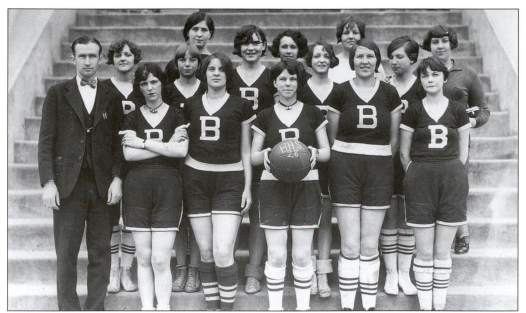

BREVARD HIGH GIRLS' BASKETBALL TEAM. The team is, from left to right, (front row) Coach Tilson, Mildred Clayton, Lillian Ponder, Josephine Clayton, Vera Jones, and Dot Fetzer; (middle row) Molly Snelson, Liza Nicholson, Frances Morris, Sue Hollingsworth, Beulah Mae Zachary, and Adelaide Silversteen; (back row) Mary Osborne Wilkins, Ethel McMinn, and Ruth Snelson. Vera Jones Stinson remembers that when she started playing, the girls wore full black bloomers with their blouses. When they changed to wearing shorts: "We were so busy trying to hide behind each other out of embarrassment, we lost the game." (HPC.)

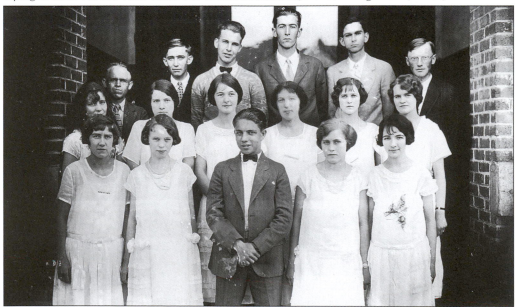

BREVARD HIGH GRADUATING CLASS OF 1925. By 1938, Brevard High's graduating class had replaced white dresses and suits with caps and gowns. In the front row, second from left, is Catherine Moffitt Henderson. She was a familiar figure who worked for many years in a local bank. (HPC.)

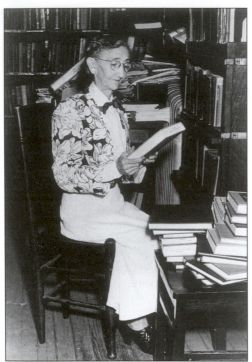

MISS DAISY. Miss Daisy Norton served as Brevard's librarian for many years. Becky Huggins remembers her as a tiny, birdlike lady who was constantly murmuring "shhh." Jack Hudson remembers her long skirts and high collar blouses with lace at the throat and cuffs and pince-nez glasses. Miss Daisy would inspect each book he had selected and frequently order him to put one back as "unsuitable." (HPC.)

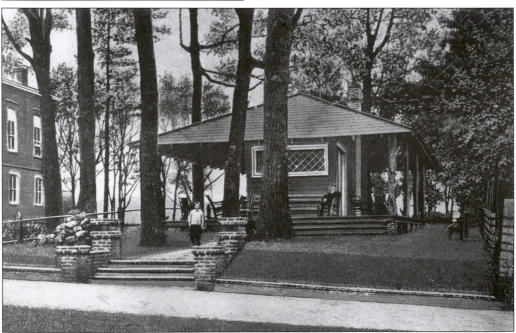

FIRST COUNTY LIBRARY. This little building next to the courthouse was constructed as a real estate office in 1911. It was acquired in 1912 by the United Daughters of the Confederacy, who used it first as a Confederate memorial library. It served as the county library from 1914 to 1956. Brevard ladies donated books to get it started. Becky Huggins remembers it as "a tiny building, so dark inside you couldn't see your hand in front of your face." Annie Gash was one of the first UDC librarians. (HPC.)

BREVARD INSTITUTE. This is a picture of West Hall before it was brick veneered. The building was located on the site of the present campus of Brevard College. (AC.)

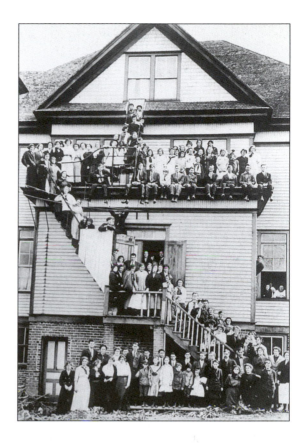

TAYLOR HALL ON THE BREVARD COLLEGE CAMPUS. Taylor Hall served as the boys' dormitory and was one of the earliest buildings on the campus. (AC.)

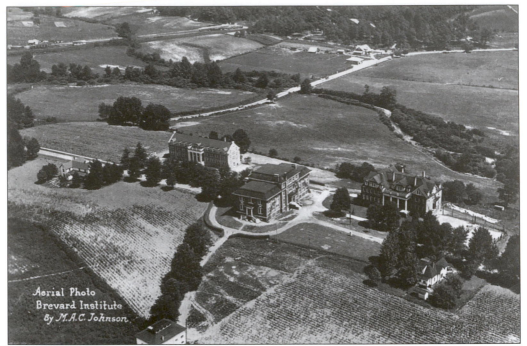

AERIAL PHOTO OF BREVARD INSTITUTE. The Depression forced its closure in 1933. Shortly thereafter Weaver College and Rutherford College merged with the Institute to form Brevard College, supported by the Methodist church. The photo was taken during the early 1930s by pilot Mac Johnson. (HPC.)

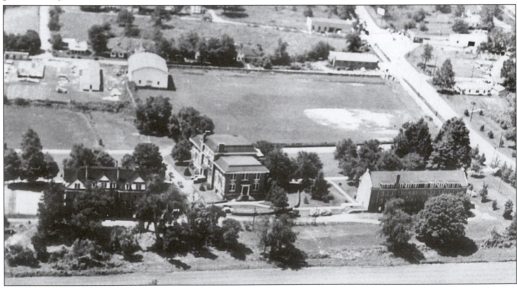

AERIAL PHOTO OF BREVARD COLLEGE. An aerial view taken in the 1940s shows the gymnasium (white building with curved roof) with the athletic field to the right. In the center of the campus is Spencer Hall (later Dunham), which housed the administration building, classrooms, and an auditorium. Taylor Hall is to the right and West Hall is to the left amid the trees. A portion of the farm operated by the college is just visible in the foreground of this picture. (AC.)

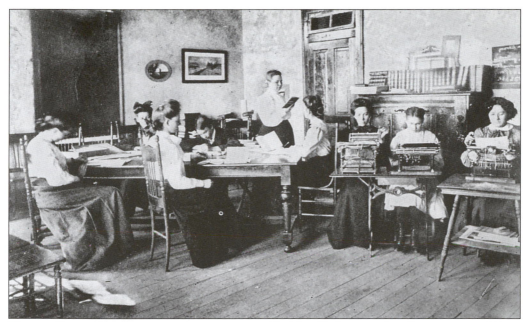

TYPING CLASS. The first typewriter was invented by New York gun makers Remington and Sons in 1874. This typing class at Brevard Institute was probably in the early 20th century. (HPC.)

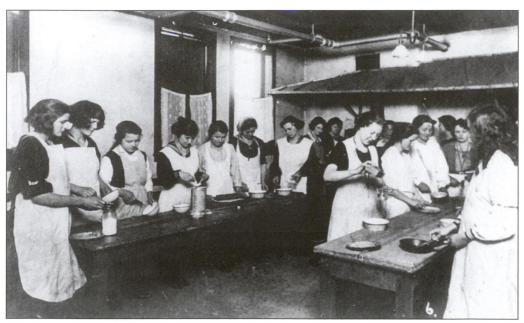

HOME ECONOMICS CLASS AT BREVARD INSTITUTE. Although Brevard Institute began as an elementary school for girls called the Epworth School, by the time it moved into the Red House, boys were admitted as well. By 1900, enrollment had grown to 79. Brevard Institute, located on what became the Brevard College campus, offered four years of high school work in agriculture, home economics, business, and music. It was a college preparatory school and operated a farm at which the boys could work to earn money for school expenses. (HPC.)

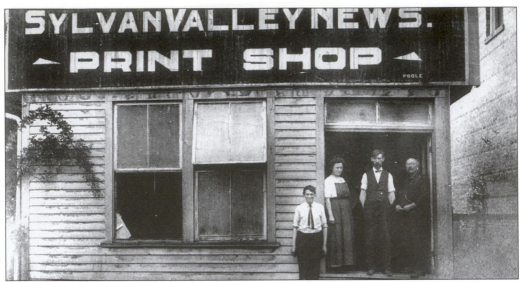

SYLVAN VALLEY NEWS. Shown from left to right are Durward Bracken, Miss Osie Miner, W.T. Bosse, and J.J. Miner (owner and publisher). The first newspaper in the county, *The Transylvania Pioneer,* was established in 1887 by E.S. Warrack from Wilmington, North Carolina. That paper went through several owners, finally becoming *The French Broad Hustler.* When *The Sylvan Valley News* began in 1895, *The Hustler* moved to Hendersonville. *The Sylvan Valley News* became *The Brevard News* in 1916. Charles M. Douglas bought it in 1931 and named it *The Transylvania Times,* which is its name today. Ed M. Anderson bought the paper in 1941 and it has remained in the Anderson family. Stella Anderson Trapp has owned and operated the paper since the 1980s. *The Transylvania Times* is located in Brevard but covers the entire county. (HPC.)

FIRST HOSPITAL IN THE COUNTY. The hospital called Riverside was operated by Dr. Stokes, a Seventh Day Adventist. The building became part of the Ralph Ramsey House just outside of Brevard. After moving the hospital to Country Club Road and renaming it the Brevard Hospital, Dr. Stokes sold it to Dr. Thomas Summey and Dr. George Lynch, who called it Transylvania Hospital. (AC.)

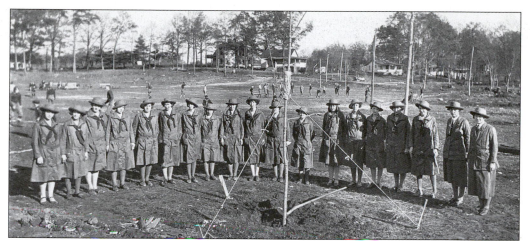

GIRL SCOUT TROOP ON ARBOR DAY, 1925. Troop Laurel I has just planted a tree for Arbor Day at Broad Street Park. They are, from left to right, Edna King, Ethel McMinn, Roberta Bryant, Christine Snelson, Ruth Snelson, Catherine Osborne, Edna Mason, Beulah Mae Zachary, Nancy Macfie, Elizabeth Shipman, Ellen English, Helen Allison, Adelaide Silversteen, Annie Yongue, Mary Johnson, Louise Hughes, Margaret Miller, Annette Patton, and Bertie Ballard. (AC.)

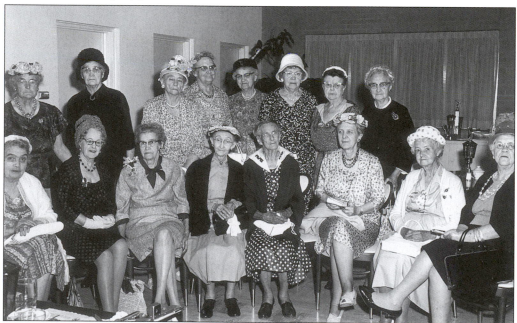

BREVARD LADIES. These ladies were Brevard Institute graduates. The photo was taken in 1964 by John Anderson. From left to right are (front row) unidentified, Arabell Aiken Houston, Alura Morris, Daisy Norton, Sadie North, Jesse Chapman Ward, Leona Allison, and Agnes Wood Hunter; (back row) Lula Miller, Eva Loftis Nicholson, Leila Pickelsimer English, Hattie Aiken, Bertha England Trantham, Ara Davis Hamlin, Hattie Glazener Kitchen, and Edith England Patton. The social life of Brevard ladies revolved around church groups, the United Daughters of the Confederacy, the Daughters of the American Revolution, and book clubs. Local book clubs have continued into the 21st century, although the hats and gloves have disappeared. (HPC.)

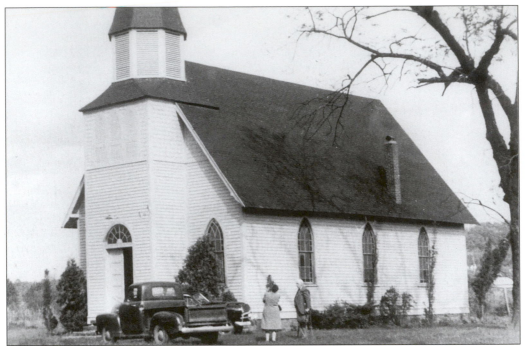

DAVIDSON RIVER PRESBYTERIAN CHURCH. Located near Walnut Grove on the site that became the settling basin for the Ecusta Paper Mill in Pisgah Forest, the earliest church building was constructed in 1826–1827. A second one was built in 1855 and burned in 1891. The building in this photograph was torn down in 1975. (HPC.)

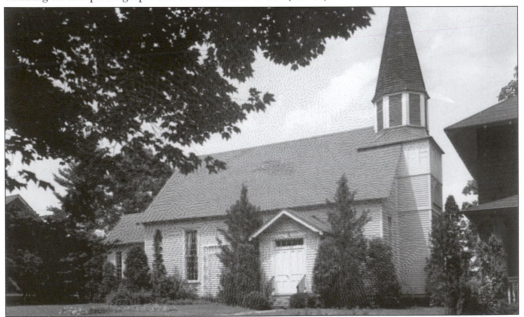

BREVARD PRESBYTERIAN CHURCH. The Presbyterian Church in downtown Brevard was built in 1891 on Probart Street. The Davidson River congregation merged with the Brevard congregation in 1931 to form Brevard-Davidson River Presbyterian. They bought the Old Franklin Hotel and tore it down to build the present church building in 1956. (HPC.)

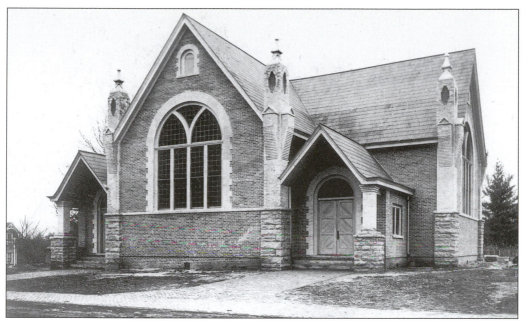

FIRST BAPTIST CHURCH. This beautiful church was built on Gaston and Jordan Streets in 1907. B.W. Thomason was the minister for many years and also served as mayor of Brevard. The church was torn down to make room for the present church building. (HPC.)

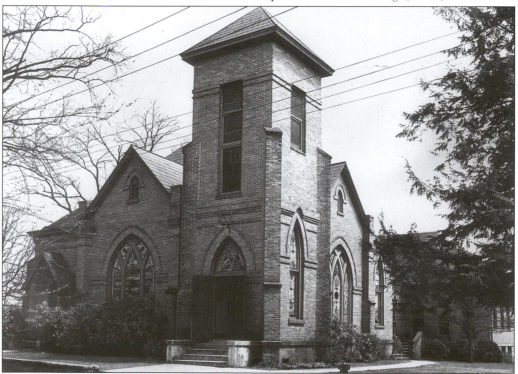

FIRST METHODIST CHURCH. This classic Gothic-style brick church was donated by the Methodist congregation to the Brevard Youth Association when they moved to their new church building on Broad Street. The building burned in the early 1960s. (AC.)

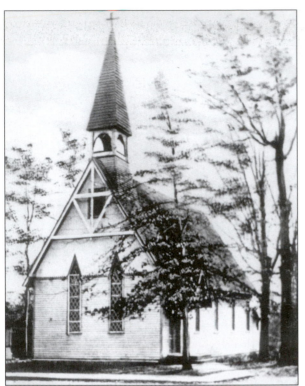

ST. PHILIP'S EPISCOPAL CHURCH. The original white frame church, known as St. Paul's in the Valley, was located about two miles outside Brevard. After the war, Charleston families no longer had the means to travel to the mountains. The future lay within the town. The frame Gothic revival building was consecrated in 1891. It was named for St. Philip's Episcopal Church in Charleston, South Carolina, (founded in 1791). The church contained a Tiffany window depicting "Hospitality and Charity." The window was listed in the 1910 Alstir Duncan's guidebook to Tiffany windows in the United States. Because of an overstoked furnace, the church building was destroyed by fire on Christmas morning 1925. (MJM.)

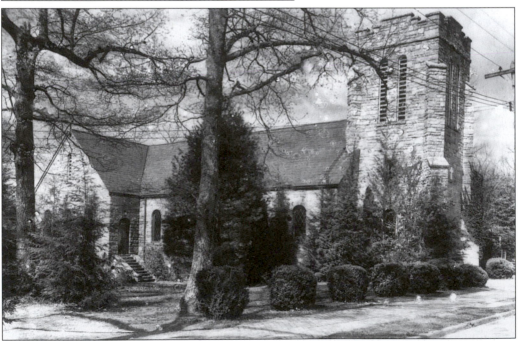

ST. PHILIP'S EPISCOPAL CHURCH. Designed by Charlotte architect Louis H. Asbury, this church was built between 1926 and 1928 to replace the church that had burned. It was built from local stone with a Norman-style front tower and is listed on the National Register of Historic Places. (Courtesy of Pat Austin.)

Six

MOUNTAIN LIVING
Recreation and Moonshine

Perhaps because life was hard, mountain people always cherished a sense of fun. Music, brought with them from their Scottish, Irish, and English places of origin, was a part of their life from the start. Brevard's African-American community shared a rich tradition of gospel music; shape-note singing still goes on; and fiddle, banjo, and guitar accompany traditional Appalachian circle dancing with its energetic clogging, also known as "buck dancing." Classical music grew widely available as Brevard Music Center and Brevard College became established. Storytelling and ballads were as important as crafts, such as quilting and weaving, an integral part of survival in a harsh environment. Hunting and fishing, originally necessary for survival, have remained a constant pastime, and other outdoor sports like hiking, biking, and boating continue to be vital to residents and visitors. Always there were the traditions of barbecues, dinners on the ground at churches, family reunions, and "singings." And we must not forget the art of distilling "corn likker," which was originally quite legal.

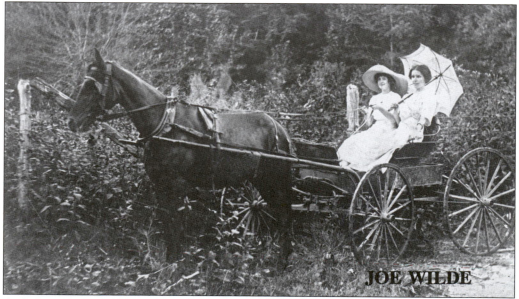

AFTERNOON OUTING IN 1908. In this splendid photograph, Joe Wilde documented an afternoon carriage ride enjoyed by two of his nieces. (WILDE.)

79

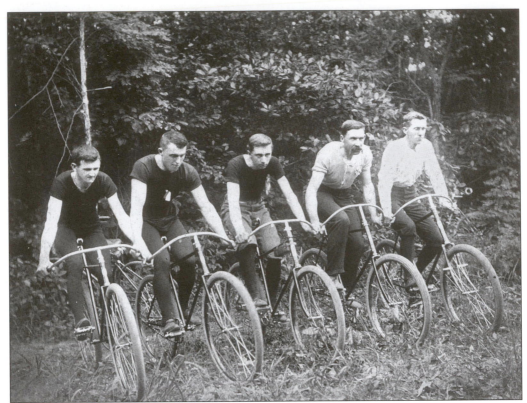

BIKERS ON JULY 4, 1893. Outdoor sports continue to be a crucial part of what draws people to Brevard and keeps them here. These bikers were on a half-mile track called Carrier's Track. Eugene Sawyer had just been timed at 1 minute, 19 seconds. (HPC.)

SURREY WITH THE FRINGE ON TOP. The gentleman standing beside the surrey is not known. The passengers are Ethel Wilde, her brother, and other family members. (WILDE.)

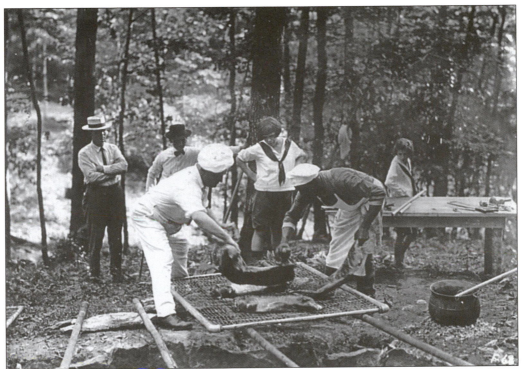

BARBECUE AT SILVERMONT. William Breese was a close friend of Joseph Silversteen and they had a barbecue every year at Silvermont. Breese is on the left in the cook's hat. A Southern "pig-pickin'" remains a cherished part of entertaining in Transylvania County. (MJM.)

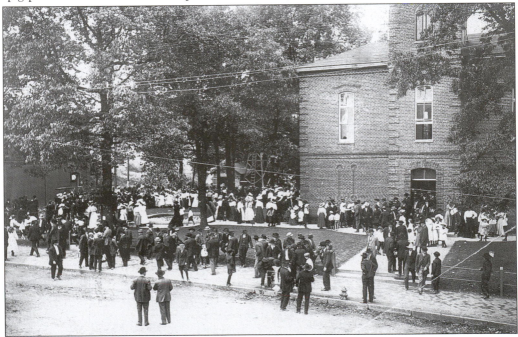

BARBECUE AT THE COURTHOUSE, 1908. A meeting and barbecue were held at the Transylvania County Courthouse to promote the railroad. (MJM.)

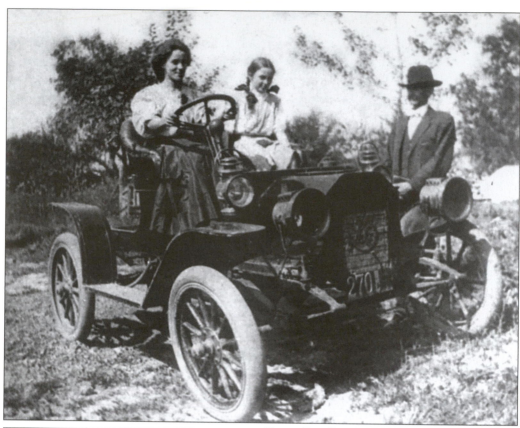

FIRST GAS-POWERED CAR IN THE COUNTY.
Dr. English shows off his Reo car to a mother and daughter in 1908. The doctor's Reo was the 270th gas-powered car in North Carolina. Dr. Edwin Strawbridge English, who practiced medicine in Brevard for 43 years, was born in the Davidson River area in 1869. His father was a Methodist minister who founded the English Chapel located in what became Pisgah National Forest. Dr. English received his medical degree from the University of the South followed by further training at the McGuire Clinic in Richmond, a branch of University of Virginia. He took specialty training at New York University in diseases of women and children. He traveled to Philadelphia to study X-ray technique when it was first introduced and purchased an X-ray machine for his own practice. (MJM.)

OFF ROAD ADVENTURE? Actually this Model T Ford wrecked on Turnpike Road near Rosman in 1921. Perry Fullbright was the driver. (WILDE.)

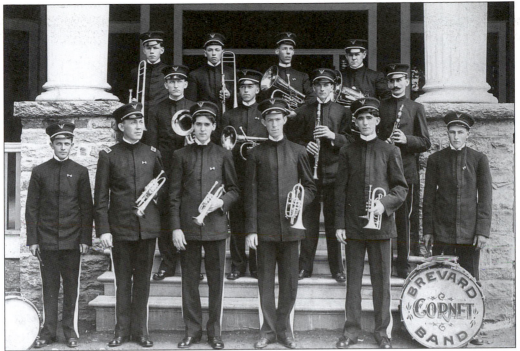

BREVARD CORNET BAND IN 1910. The band is performing in front of the Franklin Hotel. The band is, from left to right, (front row) Brance Tinsley, band leader Hume Harris, Grady Kilpatrick, Warrior King, Beverly Trantham, and Charlie Ashworth; (middle row) Charlie Jolley, Carl Morris, and Jimmy Hamlin; (back row) Claude Cantrell, John Ashworth, Spurgeon Osborne, and "Pat" Bradley. (MJM.)

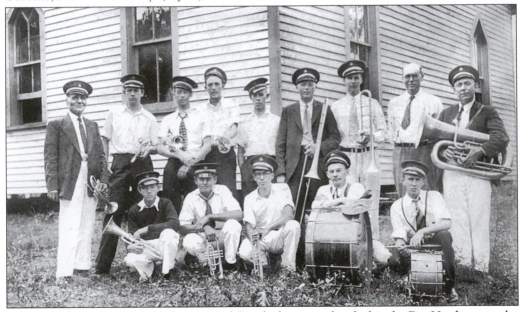

BREVARD BAND IN 1930. The Brevard Band plays at a local church. Dr. Hardin was the trombone player. There was a bandstand beside the courthouse and local musicians often performed at the Franklin Hotel as well. (HPC.)

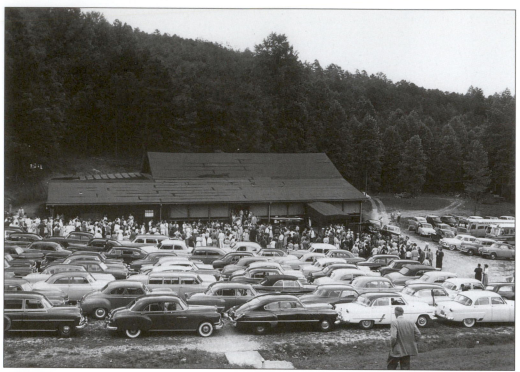

BREVARD MUSIC CENTER. The Music Center was founded as a summer music camp for boys in 1936 by Dr. James Christian Pfohl, who was a music professor at Davidson College. Summer sessions were held on the campus until World War II and then at Queens College for a short time. In 1946, the first Brevard Music Festival was held at what is now the Music Center. This is a picture of the first open-air auditorium, called Straus. Though the old auditorium is still used for entertainment events and student recitals, a state-of-the-art auditorium called Whittington-Pfohl was built in 1972. The Music Center attracts fine musicians and outstanding students from all over the world for its summer season. (Courtesy of Pat Austin.)

BREVARD MUSIC CENTER. This is still a familiar sight at Brevard Music Center during its summer season. You can roll down your windows as you drive through and hear students practicing outdoors or in practice cabins. (Courtesy of Pat Austin.)

BREVARD'S MONARCH. This magnificent elk lived at "Deer Park," the home of William Allison. By 1912, when this photo was taken, the elk in Western North Carolina had been hunted into extinction. Thanks to an elk reintroduction project, these wonderful Western North Carolina natives are now being returned to their native habitat. (MJM.)

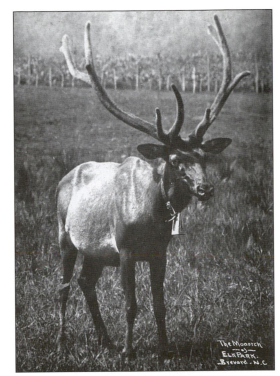

ELK LODGE AT DEER PARK. This is a photograph of C.M. Siniard and boarders at Deer Park, which was owned and developed by Dr. William Hicks Allison. The lodge was on the mountain-top above what is now Straus Park. (MJM.)

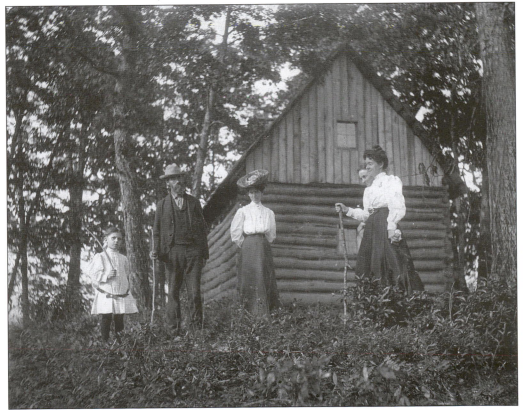

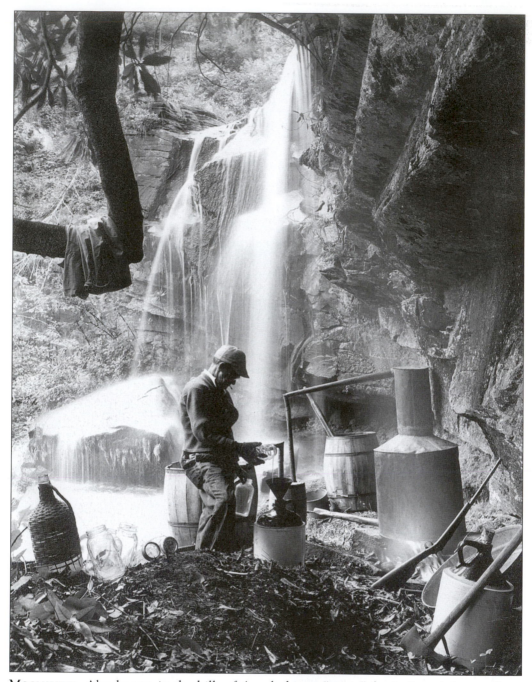

MOONSHINE. Also known in the hills of Appalachia as "stump" (as in "runnin' stump"), or simply as "corn likker," it was never called "white lightning" by anyone but the revenuers. This picture of Brance Tinsley with his still at Boren Mill Shoals on Old Toxaway Creek was taken by his son Jim Bob Tinsley, a well-known entertainer and local historian who knew Roy Rogers and Dale Evans. Tinsley was an archivist of Western music. (Courtesy of Jim Bob Tinsley.)

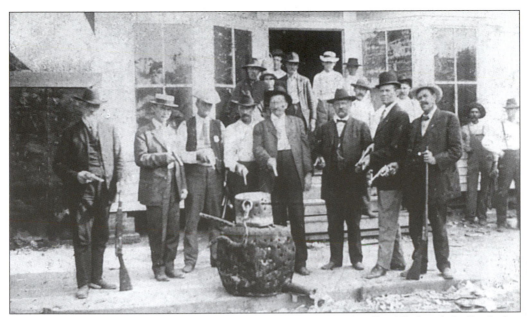

CAPTURED STILL. Armed lawmen gather around a confiscated still riddled with bullet holes. Folks tell the story of two limousines appearing in Cedar Mountain during Prohibition, both with license plates reading #1. The governors of North and South Carolina had both happened to send their chauffeurs to obtain moonshine from a premier maker on the same day. (HPC.)

CAPTURED STILL IN 1928. Until Prohibition, corn liquor could be made legally under a government license. There was a federal distillery in the building that now houses the offices of Castle Rock Institute, formerly Walter Cantrell's Woodworks. Sheriff Tom Wood is to the far left and Chief of Police Bert Freeman is to the far right. Freeman was at least 6 feet, 6 inches tall and was known as "Hi-Pockets" because he towered over everyone. (HPC.)

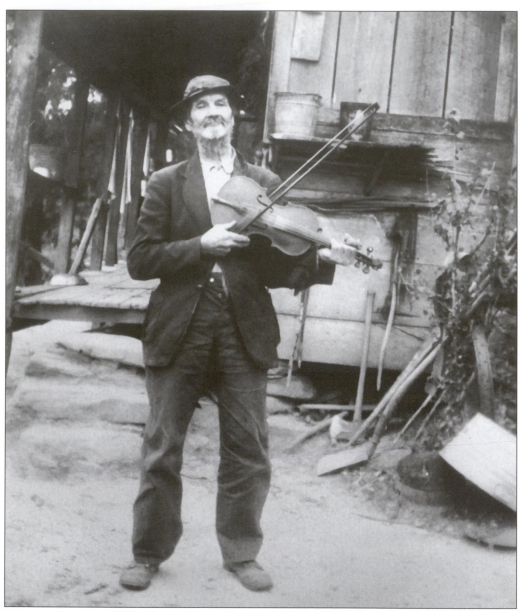

FAMOUS FIDDLER. Will Chappell owned over 2,000 acres in the southwestern part of the county that early settlers called *The Auger Hole*: the gorges in that area were so deep they looked as if they had been bored into the mountains by a giant auger. Will's mother was a full-blooded Cherokee who returned to the reservation after his father died in the Civil War. She left Will in the care of his paternal grandmother. In addition to farming and mining for lead on the Toxaway River, Chappell was a renowned fiddler who played all over the county, sometimes all night long. Family tradition holds that he owned the 37th Stradivarius to be manufactured, though in those days violins were sold even by Sears and Roebuck and labeled as being manufactured by the famous violin maker. He won fiddling competitions throughout the area and taught old tunes to family members who were part of the Grand Ole Opry. It was said that with a little moonshine and almost nothing to eat, Will could play for three days straight. He had nine children with his wife Evelyn and lived to be 100 years old. (HPC.)

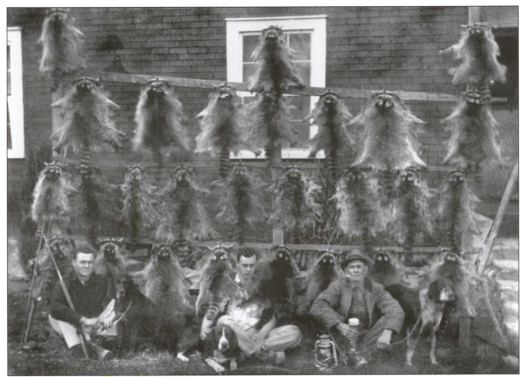

AFTER THE RACCOON HUNT. Hunters pose with their raccoon skins and coon dogs. Hunters are, from left to right, Ray McCall, Curtis McCall, and their father, Jason McCall. The dogs from left to right are Rock, Dugan, and Bell. (WILDE.)

FOX HUNT. This fox is held by the fourth man from the left while successful fox hounds pose in front. This hunt may have been a bit less formal than traditional hunts on country estates in England, but the outcome seems to have been the same for the fox. (WILDE.)

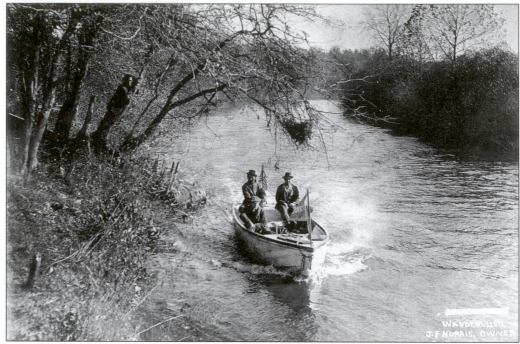

TOURING THE FRENCH BROAD RIVER. Owner J.F. Norris, who lived in Pisgah Forest, took people out on the French Broad in his boat *Wanderlust*. (HPC.)

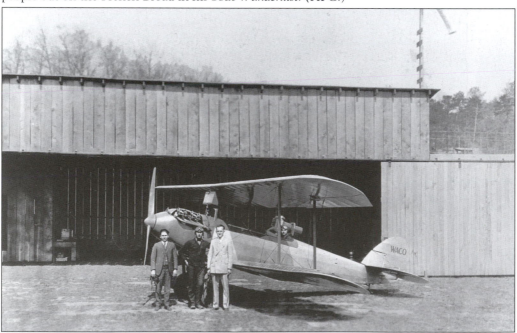

FIRST PRIVATE PLANE IN THE COUNTY. The plane, a Waco Model 10, belonged to commercial pilot and professional photographer Mac Johnson. His aerial camera can be seen mounted in the cockpit. With him are Jerry Jerome on the right and Joe H. Tinsley on the left. Johnson had an aerial photo published in *Life* magazine of a place where the bends of the French Broad River spell out "U.S.A." (AC.)

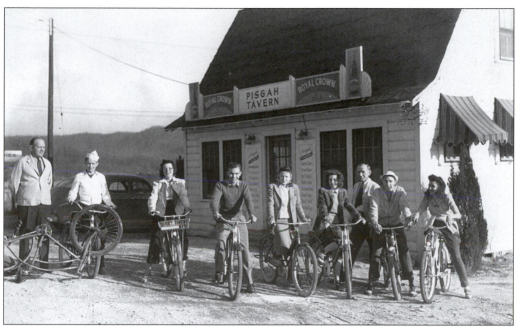

PISGAH TAVERN. Located on old Highway 64 in the early 1940s, Pisgah Tavern was a hangout for young people. The tavern sold beer (according to one former teenager) "even when it wasn't legal." From left to right are Mr. Hunter (owner), Johnny Hunter (his son), Mary Vannah, Leslie Coleman, Kathleen Wilson, Jean Dixon, Mr. Fred Hunter (also owner), Buddy Green, and Irene Tinsley. (AC.)

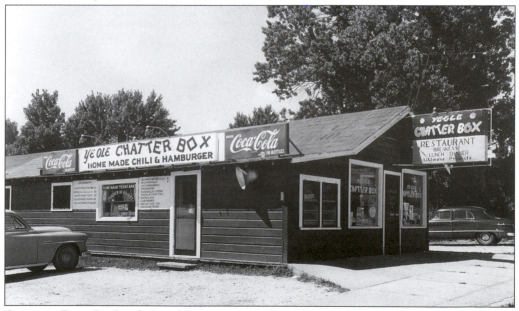

CHATTER BOX. On South Broad Street opposite the old Brevard High School, the Chatter Box was a teen hang out operated by Mrs. Margaret Sellers, who made the best lemon pies in the county. It was later run by the Bramletts. Students from the high school who didn't go home for lunch went to the Chatter Box, also known for their great hot dogs, or to Varner's Drugstore. The building is now the 4-Rent rental business. (AC.)

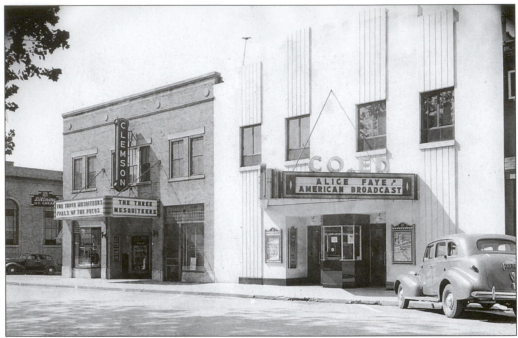

GOING TO THE MOVIES. This is the Clemson Theater on West Main in 1941. Robert Gash saw the first feature length "talkie" movie here. It was *The Jazz Singer* ("Wait a minute. You ain't heard nothin' yet") with Al Jolson, produced in 1927. In that era, tickets were 10 cents and preachers' kids got in for free, as did the school safety patrol. The Co-Ed Theater on the right was built later. The Clemson Theater was torn down, but the Co-Ed still houses Brevard's movie theater, as well as the original ticket-seller's cage from the Clemson. (AC.)

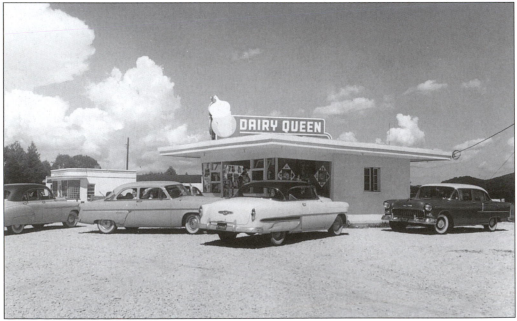

DAIRY QUEEN. Located near the college on Broad Street, this was another popular hangout for local kids. (AC.)

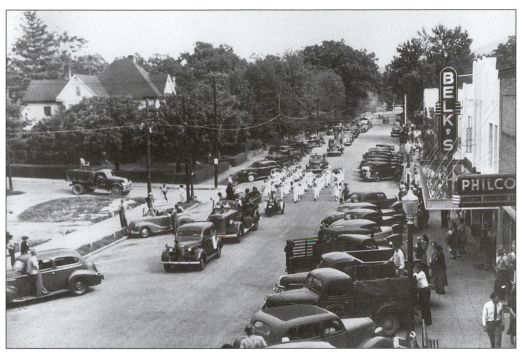

PARADE DURING POST-WAR YEARS. This parade took place in the late 1940s. The band was sponsored by Ecusta Corporation, which later donated the instruments, uniforms, and the services of the band director to Brevard High School. (AC.)

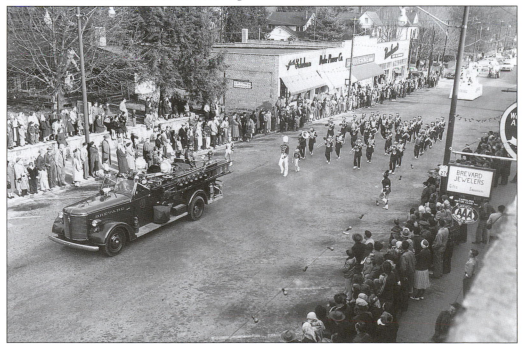

EVERYONE LOVES A PARADE. A fire truck followed by the Brevard High marching band leads the parade down Main Street past Brevard Jewelers. In the early days, there were no floats and no band and Santa Claus rode on the fire truck. (AC.)

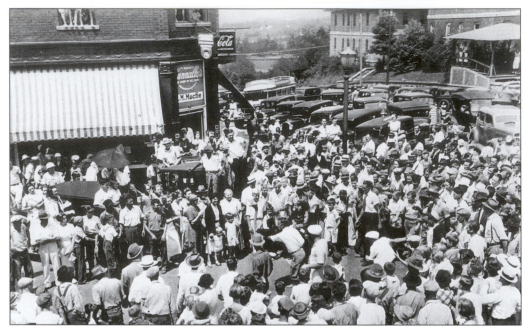

OSTRICH RACE, 1936. A crowd gathered in front of Macfie's Drugstore as William Austin took pictures from a nearby upstairs window. One of the ostriches is visible in the center of the crowd. Someone tried to ride on one of the ostriches, which ran into a parked car. The rider was thrown off and broke a leg. Macfie's also sold bus tickets; a bus is parked at the back of the store. (AC.)

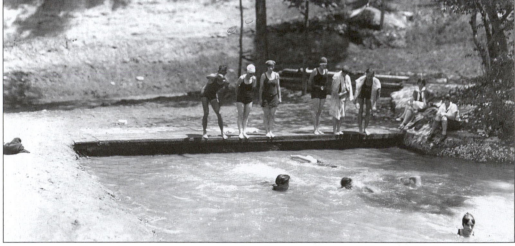

ROCKBROOK CAMP. Summer camps started early in and around Brevard. Early in the 20th century there was Camp Sapphire, later Camp Straus; The French Broad Camp near the river; and Camp Transylvania, later the Music Center. Camp Keystone was founded in 1916 on Cashiers Valley Road. Rockbrook Camp was founded in 1921 by Mr. and Mrs. Henry N. Carrier on their estate outside Brevard. That same year Camp Illahee was established by Frances and Hinton McLeod. Professor D. Meade Bernard from Jacksonville, Florida, founded Camp Carolina in 1924, and Mary Gwynn opened Gwynn Valley Camp (then called Gay Valley) in 1935. Rockbrook and Keystone have always been camps for girls while others are now co-ed. These summer camps, as well as more than 15 others, continue to operate, most within a few miles of Brevard. (MJM.)

Seven
BREVARD MATURES
Prosperity and Growth

Joseph Silversteen's magnificent home on East Main Street symbolized Brevard's new prosperity and has remained an important symbol for the community, its intent to guard its heritage and to care for its own. Threatened with destruction in the early 1980s, Silvermont was saved by a group of determined citizens and has since been restored and placed on the National Register of Historic Places. It provides a place for senior citizens to come on a daily basis for fellowship and a noon meal. It also offers a place for weddings and receptions, for mountain music (on Thursday evenings), and for the County Archives and the Transylvania County Historical Society. Its tennis courts and basketball goals invite local residents to come for recreation as well. With the arrival of Ecusta Paper Mill, which purchased land for its operations in 1938, Brevard's modern era of prosperity began. DuPont established an X-ray film division in the southwestern end of the county in 1956. American Thread, a manufacturer of threads and yarn, arrived near Rosman in 1964. As World War II ended, Brevard's future looked truly bright.

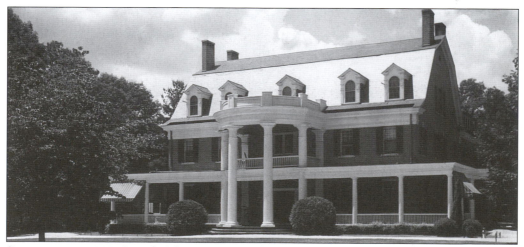

SILVERMONT, 1917. Joseph Silversteen moved from Pennsylvania to Transylvania County in 1902. The Silvermont mansion was located on over eight acres on East Main Street in Brevard. Until its completion in 1917, the Silversteens lived in Rosman where Silversteen's lumber company was headquartered. Silversteen was a civic leader in Brevard all of his life. At his funeral at St. Philip's Church, rector Frank McKensie, the rabbi from Asheville, and a leader of the Masonic Lodge all officiated together. (AC.)

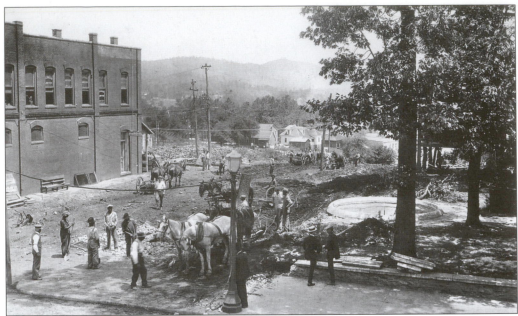

PAVING NORTH BROAD. In the summer of 1928, North Broad was paved down Jailhouse Hill. The dirt was moved with horses and dragpans. Note the fishpond on the right among the trees. Judge Gash's father reportedly once fell into the fishpond while waving at some ladies in the windows of the courthouse. The side of the McMinn building is visible to the left. (AC.)

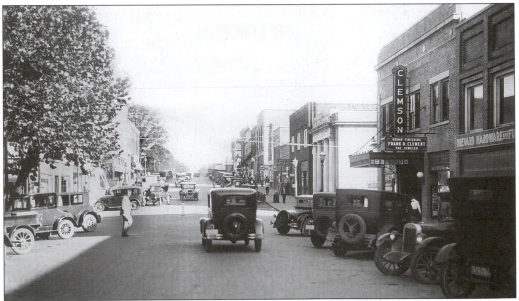

DOWNTOWN BREVARD IN THE ROARING TWENTIES. This is a view from West Main Street looking east. This building housed the offices for the telephone company and Clement Jewelers. Clemson Theater got its name because Frank Clement's son Vernon was in business with him. The Clemson Theater has been torn down, but a modern theater still exists next to that location. Until the 1960s, Brevard's African-American citizens could only view movies from the balcony and had to enter the theater from a separate entrance on Caldwell Street rather than Main Street. (AC.)

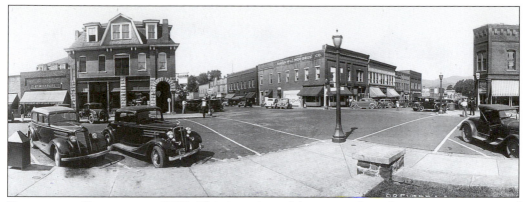

DOWNTOWN BREVARD IN 1935. This is a view of downtown from the main intersection of Main and Broad Streets across from the courthouse. To the far right under the awning is Macfie's Drugstore, Long's Drugstore is to the left of the street light. One A&P is to the left of Long's Drugs. In the foreground is the Waltermire Hotel. A second A&P is to the left of the hotel on East Main. (AC.)

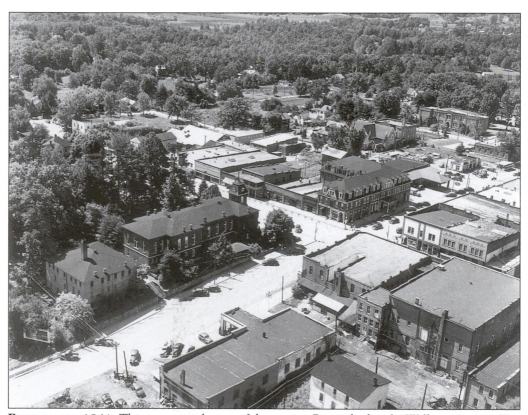

BREVARD IN 1941. This is an aerial view of downtown Brevard taken by William Austin. You can easily identify the Waltermire (formerly Aethelwold) Hotel at center right, the courthouse opposite, and the McMinn building across the street from the courthouse. (AC.)

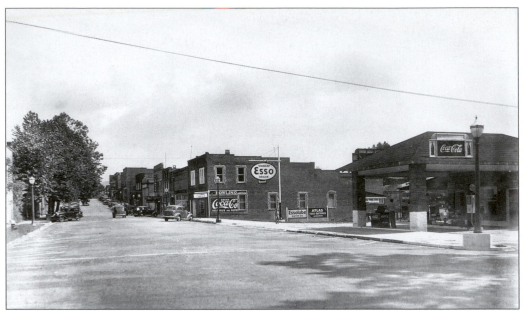

MAIN STREET IS STILL TREE LINED IN 1940. There is some disagreement as to whether or not there were originally trees all along Main Street. But what trees did exist downtown were cut in the 1950s so that the town would look "more modern." During the 1980s they were replanted. This photo was taken near the site of the present post office on West Main Street with Esso and Coca-Cola signs prominent. Note the bowling alley sign above the Coke sign at center. The old fire station was to the right where the road bends. (AC.)

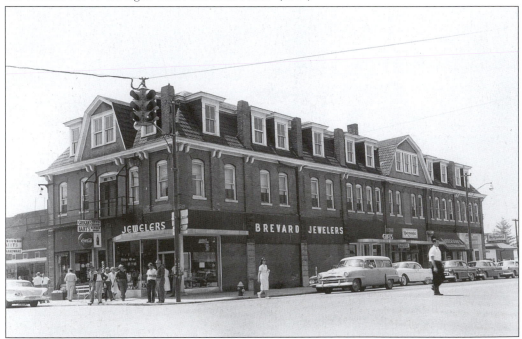

WALTERMIRE HOTEL. This photograph was taken in 1960 before the third floor with its classic Mansard roofline was removed by order of the fire marshal. The A&P behind the building had burned. The third floors were constructed of wood and were considered a fire hazard. (AC.)

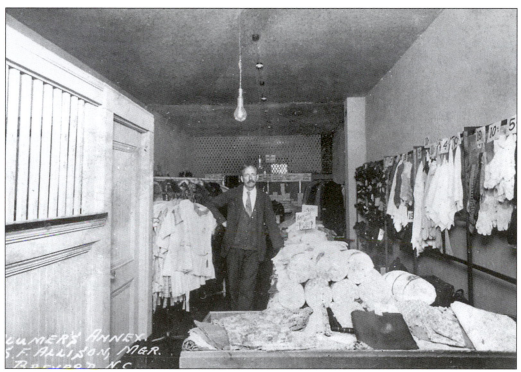

PLUMMER'S DEPARTMENT STORE. The store manager poses next to display tables at the store's annex on West Main Street. (HPC.)

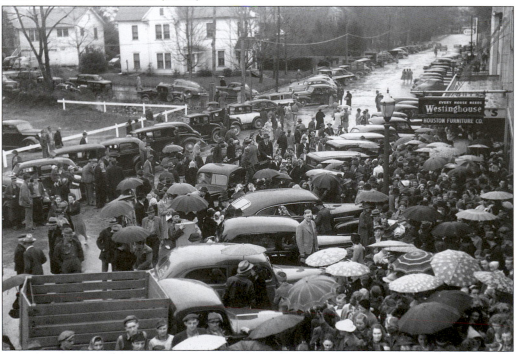

GRAND OPENING. Houston's Furniture Company held its grand opening on a rainy day, April 19, 1941. (AC.)

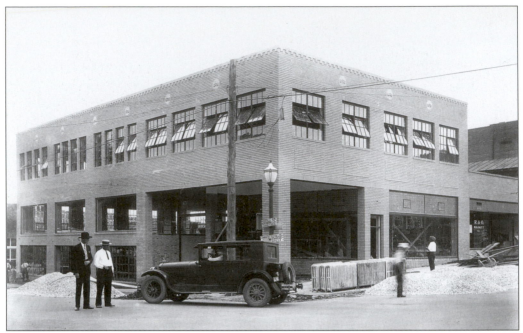

JOINES MOTOR COMPANY. The building was constructed in 1927 as a Ford dealership on West Main. It later became Wheeler's Hosiery Mill. After the mill closed in the mid-1950s, the building housed Pearlman's Furniture, followed by Rice Furniture, which is still in operation. The ramps from the old motor company remain in the building. (AC.)

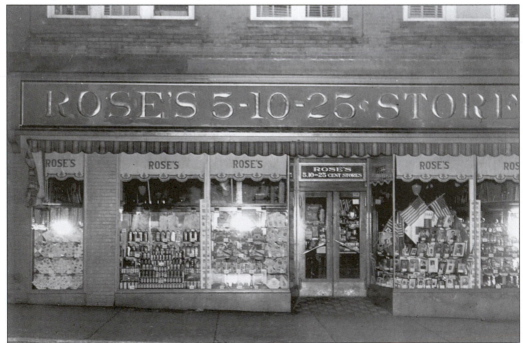

ROSE'S "5 & 10 CENT" STORE IN THE 1940S. Rose's was a chain store that began in Henderson, North Carolina, in 1915 and expanded throughout the Southeast. This store was on West Main Street where the Chamber of Commerce is now located. (AC.)

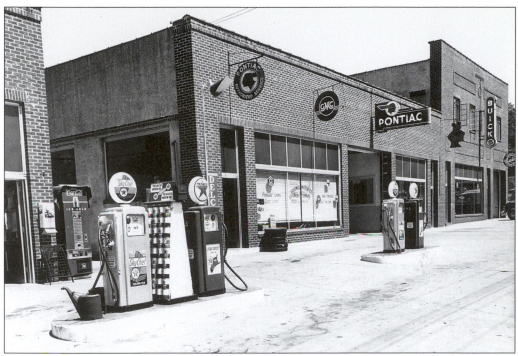

GOODWILL MOTOR COMPANY. Vernon Fricks was the owner of this dealership located on South Broad Street. (AC.)

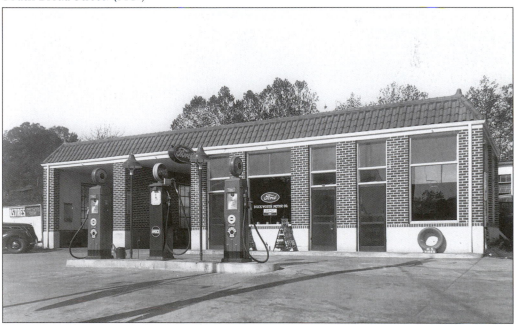

DUCKWORTH MOTOR COMPANY IN 1938. Though it looks like a service station, Walter Duckworth also sold cars. Typically he would have only a couple of new cars on the lot at a given time. The building is located on North Broad Street in what is now a video store. Its distinctive tile roof was removed in a renovation, but a nearly identical tile roof can be seen in the building across the street, formerly the Red Diamond gas station. (AC.)

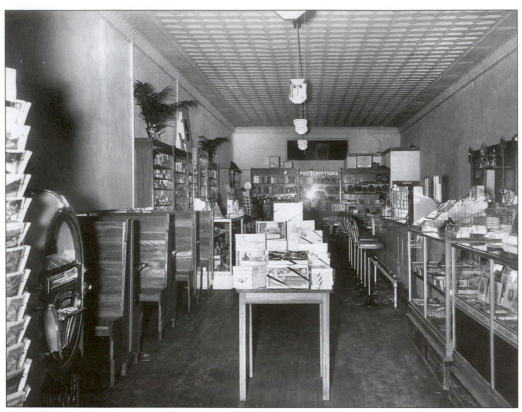

BREVARD DRUGSTORE IN 1941. This is the interior of Brevard Drug Store with its glass cases lining the walls. The soda fountain is visible at the right toward the back. Drugstores offered a little bit of everything. (AC.)

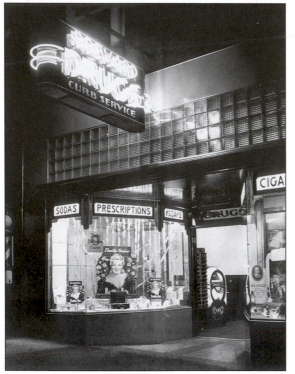

SODAS, PRESCRIPTIONS, KODAKS. The exterior of Brevard Drug Store on West Main Street in 1941 advertises a few of the items offered. It was located where the drive-through of Wachovia Bank is now. (AC.)

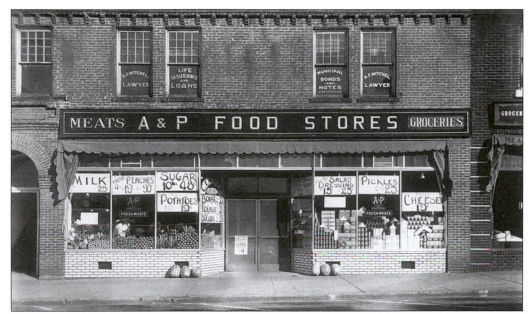

A&P Food Stores in July 1940. The A&P was located on Broad Street at this time, having moved from East Main. Lawyers' offices and insurance company offices were located above the store. There was also an A&P on East Main next to the Waltermire Hotel (see page 97). (AC.)

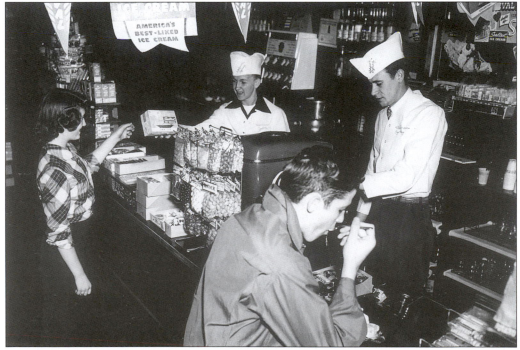

Varner's Drugstore. People dig in at a Sealtest ice cream promotion in 1951. Truitt Nelson is the soda jerk on the right. Bobby Black is the one on the left. Jack Eubanks, in the foreground, always wore his collar up to be cool. The girl to the left is Dottie Kizer. The former Varner's Drugstore is now the location for the D.D. Bullwinkel's gift shop and restored soda shop called Rocky's. (AC.)

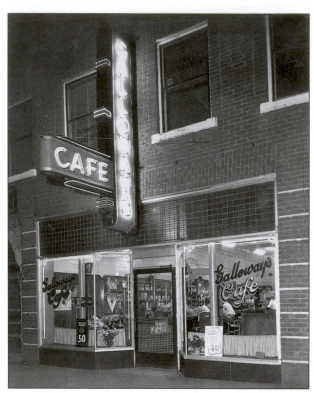

GALLOWAY'S CAFÉ IN 1942. Galloway's Café on South Broad was sold to Pete Bikas, of Greek origin, who never changed the name of the café. Bikas is remembered as producing truly memorable food. (AC.)

GALLOWAY'S CAFÉ. This is the interior of Galloway's Café, with booths to the right. The café was a favorite gathering place. (AC.)

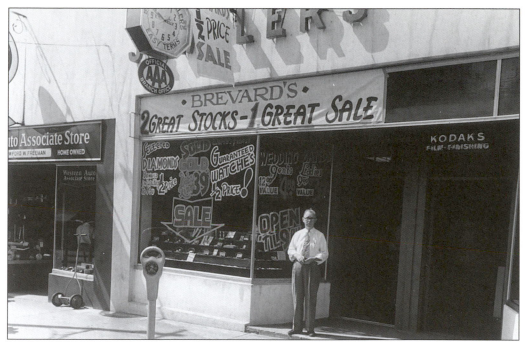

BREVARD JEWELER'S AND AUSTIN'S STUDIO. Charles Douglas operated the license tag office in the back of the jewelry store in 1951. Brevard Jeweler's later moved to the corner building and Austin's expanded into the wider space. Austin's Studio was the family-owned business of photographer William Austin and continued to be run by his family as Austin's Art Shop until 1998. This building is at 11 East Main Street opposite the courthouse. (AC.)

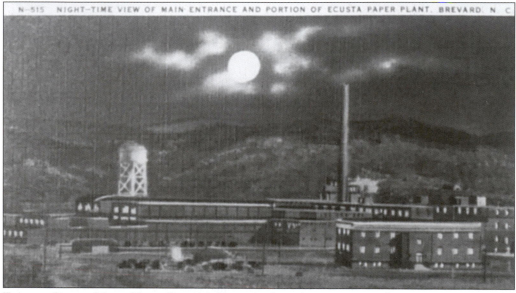

ECUSTA PAPER MILL. Harry Straus, who arrived in this country at the age of 18, built the Ecusta Paper Mill in Pisgah Forest in 1938. Ecusta made the fine, lightweight paper used in the printing of bibles, hymnals, and dictionaries, as well as for cigarette papers. The company was purchased by Olin Corporation in 1949 and later merged with the Mathieson Chemical Corporation. In its heyday, Ecusta provided employment to more than 2,800 people. (HPC.)

FIRE ENGINE AT OLD TOWN HALL IN 1928. This fire engine is a 1923 American La France model with solid rubber tires and a 750-gallon capacity pump. To the far left in white hat and coat is Fire Chief J.S. Bromfield. Jerry Jerome, a prominent local businessman, poses with the firemen. The fire engine still resides in the basement of the fire department. (AC.)

PUTTING OUT A FIRE. The Moffitt House on Country Club Road, near what is now Moore's Funeral Home, burned in 1914. The house with the turret on the back left is the T.H. Shipman Boarding House. Elsie Perry Burhans, a Brevard resident, told the story of how her sister Ruth caught a ride on the front bumper of the fire engine as it raced to a fire. Their father was rector of St. Philip's Church, and as she approached the church, they saw her waving like a beauty queen. (HPC.)

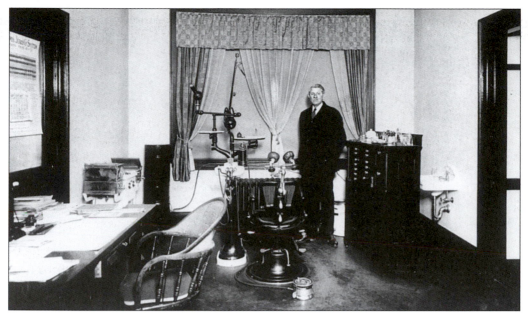

McLean's Dental Office. Dr. John McLean completed dental school at the University of Tennessee in 1899. His first dental office was in the front room of his home on McLean Road. He later shared a building with Dr. Lyday in downtown Brevard where the office in this photograph was located. Dr. McLean was the father of John McLean, who owned McLean's Machine Shop (page 42), and the grandfather of Sara Jane McLean Moser, who lived in that same home and, with her husband Bill Moster, built a business next door called the Wedge and Keg (now Casey's Restaurant.) (HPC.)

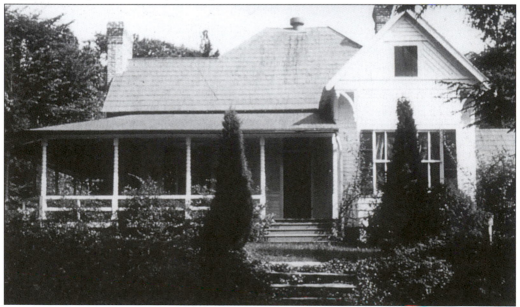

Partridge Hill. This house on Everette Farm Road was built about 1901 by a member of the Patton family. Hamilton Basso, author of *The View from Pompey's Head*, bought the house in 1935. He lived there with his wife Etolia (Toto). He was a contemporary and good friend of novelist Thomas Wolfe, who visited the home often. (Courtesy of Charlie and Jean Brendle.)

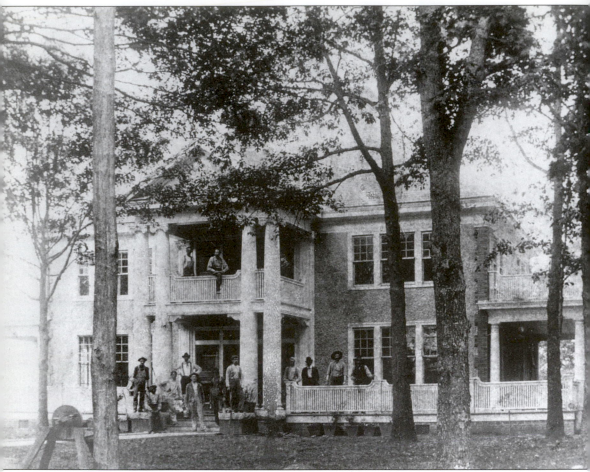

WILLIAM BREESE HOUSE. In 1902, Martha Allen Edmond Woodbridge, a widow from Richmond, Virginia, bought the property from the Toxaway Company and built this home. Her daughter Rebekah married local lawyer William E. Breese Jr., and they raised their family in the house. The house later became the Colonial Inn and is now the Inn at Brevard. This photograph of the house was taken as it was being completed. The open porches were later enclosed. (AC.)

Eight
Brevard's Richest Heritage
Its People

Brevard and its surrounding communities shared much in common with the rest of the state, yet the folks who settled in the mountains were also unique. The mountains seemed to produce independent thinkers, sometimes drawing people who happened also to be escaping from the confines of a more settled life. As time went on, mountain communities drew entrepreneurs who brought prosperity to the region. The beauty of the area with its waterfalls, trout streams, and hiking trails attracted fascinating people from all over the country and eventually a huge number of summer camps sprang up. In due course, Brevard produced some remarkable entertainers like Moms Mabley and Beulah Mae Zachary.

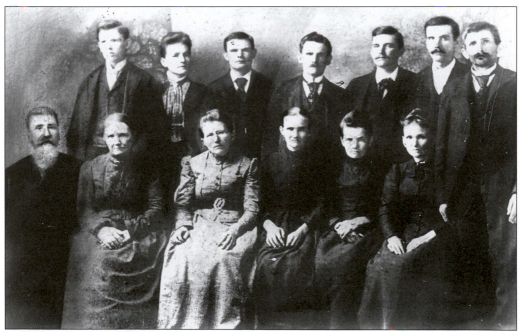

THE LYDAY FAMILY. To the left are the parents, Dr. A.J. Lyday and his wife Elizabeth Clayton Lyday. The Lyday name is a derivation of Leiden, the name of a Dutch family who settled on the upper French Broad near the mouth of Little River in 1771. The Lydays are the first family known to have settled in this area. (MJM.)

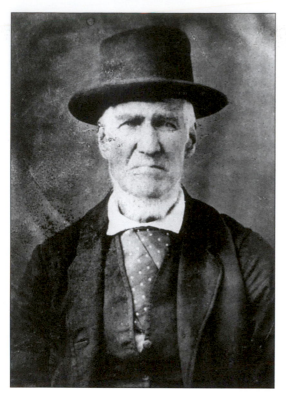

JEREMIAH OSBORNE, 1802–1890. About 1865, Osborne survived a confrontation with an outlaw gang of "Tories" who were robbing and killing people in the county. They tied him to a stake and threatened to burn him, but he bought them off with $300 in gold pieces. (MJM.)

REBECCA OSBORNE. Wife of Jeremiah Osborne, she lived in Brevard from 1807 to 1887. The women in Brevard at the beginning mastered many skills that allowed their families to prosper. They spun the thread and wove the cloth for clothing, they helped their husbands tend the crops and the livestock that meant survival, and they mothered large families (many of Brevard's founding families numbered 14 or more). They were often educated and were women of great faith. They also brought to this area their British heritage of ballad and story. (MJM.)

WILLIAM K. OSBORNE, 1838–1917. Son of Jeremiah and Rebecca Osborne, William served in a North Carolina infantry division under Capt. Francis W. Johnstone. After returning from the war, he married Mary Thomas, daughter of Robert Thomas, who was murdered by the same gang of outlaws who had nearly killed William's own father. William is probably wearing a beaver hat in this photograph. Hatteries were one of Brevard's earliest industries. There were three: Neill's, Wilson's, and Zachary's. The shops made hats from the pelts of wild animals. White hats from the stomach fur of bears were worn by doctors, preachers, and teachers. Lawyers, politicians, and gamblers wore hats of black beaver fur. Two miles north of Brevard near what became Ecusta, Neill's Hattery Shop was a kind of community meeting place. It provided a gathering place for some of the men who helped remove the Cherokee to Oklahoma in 1838 on the infamous Trail of Tears. (MJM.)

THE ROAD BUILDER AND HIS WIFE.
Solomon Jones was born March 7, 1802.
His wife was Mary Hamilton Jones.
Although he did not fight in the Civil
War, he remained a Unionist. Solomon
Jones built the Jones Gap Turnpike
through the mountains from Greenville
to the upper French Broad Valley by way
of Brevard. It was a toll road and the fees
helped support his family. He also built
the Green River and Flat Rock
Turnpikes, and Cashier's Valley Road.
He probably surveyed parts of present
Highways 64 and 25. Many of his
descendants continue to live in and
around Brevard. He owned as much as
4,000 acres of land including Mt.
Hebron in Henderson County, where he
was buried after his death on April 23,
1899. He carved his own monument,
which reads "Here lies Solomon Jones,
The Road Maker, a true patriot. He
labored 50 years to leave the world better
than he found it." (Courtesy of Vera
Jones Stinson.)

UNCLE VOL, 1863–1958. Uncle Vol
McCrary was named for Hickison Dickison
Condoff Condary C. Volney Orr. At one
point he was badly injured by the mill
wheel at the mill where Rockbrook Camp is
now located, and a bone taken from his
head after that accident remained on the
family mantel for many years. He made
good corn liquor and was even known to
drink it. He could cure thrush and stop
bleeding. He became a self-taught
veterinarian who was in demand all over
the county. His unfailing technique for
curing cows was to give them an enema. He
also spayed animals and did other routine
veterinary care. "Aye God, Janie," he once
said to a niece, "I'm a sharp man." He
bought a hunting license when he was 94.
(Courtesy of Anita Cagle.)

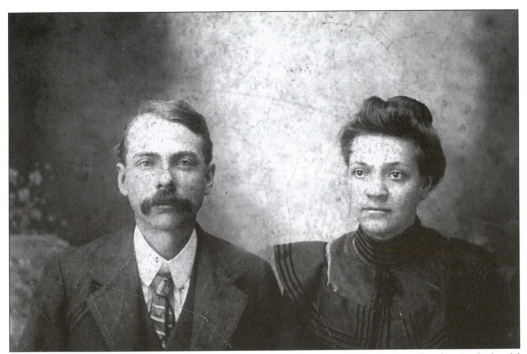

T.W. WHITMIRE AND MATTIE COOPER WHITMIRE. Thomas Whitmire bought the Aethelwold Hotel after the death of its owner in 1918 and renamed it for his son Walter. (MJM.)

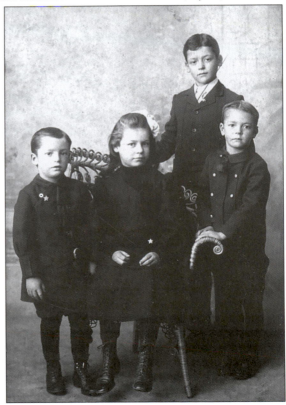

T.W. WHITMIRE FAMILY. The children are, from left to right, Ruth, Grace, Roland, and Walter. There was a younger son Thomas who is not in this portrait. Brevard native Jack Hudson remembers Mr. Thomas Whitmire as an old man with a cane who used to cross the street to Long's Drugstore and buy a packet of gum and a packet of Lifesavers every day. He would then return to rock on the porch of the Waltermire for the rest of the day while he enjoyed them. (MJM.)

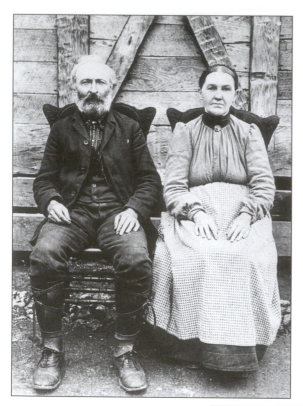

THE McCALLS. Jessie and Elvina McCall were the caretakers for one of Vanderbilt's Black Forest Lodges, lodges in Pisgah Forest used by Schenk for his foresters (see Black Forest Lodge, page 54.) The lodge is visible immediately behind them. (HPCP.)

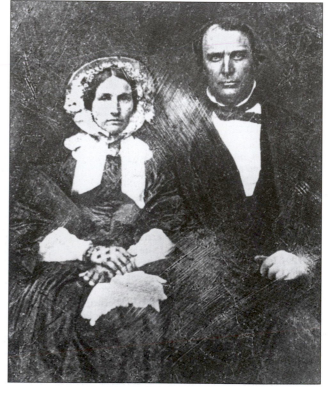

THE GASHES. Leander Sams Gash (1813–1872) and Margaret Adeline McClain Gash (1819–1890) were also among the "founding families" of Brevard. According to his great-grandson, the Honorable Robert T. Gash, Leander Gash was elected to the North Carolina Senate by "an act of God." Judge Gash explains: "The rains came and the creeks rose and Madison County's vote did not reach Raleigh in time." (MJM.)

COLUMBUS MILLARD SINIARD. Born June 16, 1859, his grandmother was part Cherokee and was said to be a princess of the tribe. He was actively involved in the development of Brevard, especially helping to designate camps for young people such as Camp Carolina, which had been his homeplace. He was involved in the spiritual life of the county, eventually becoming the oldest member of Brevard-Davidson River Presbyterian Church and writing a well-known poem called *The Good Old Bible*. He died in 1942 and is buried with his wife, Lillie Mackay, in Oak Grove Methodist Cemetery, the church where he had grown up. (MJM.)

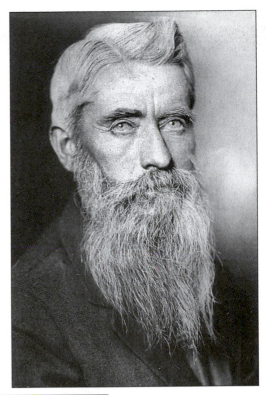

ENGLISH McGAHA AT A LOCAL WATERFALL. McGaha came to town in his wagon everyday. He was known as something of a town character who always wore the same coat, but he looks rather dashing in this picture. (MJM.)

115

JANE AIKEN HALL. Born into slavery, "Aunt" Jane was the grandmother of Selena Robinson and Moms Mabley. She had been an Aiken but married Mr. Hall some years after emancipation. She had three sons: Dennis Cleveland "D.C." Hall, Robert Pinckney "Pink" Aiken, and James P. "Jim" Aiken. Jane Hall lived to be 100 years old on land her family owned where Brevard Music Center is now located. According to the 1860 census, there were 500 slaves in the county. On the county's first tax list in 1862 there were 447 slaves and 4 free black individuals. (HPC.)

ETHEL WILDE IN 1915. Trained as a teacher in her native Tennessee, she and her husband, Joseph, came to Transylvania County in 1914 because of her fragile health. She went on to have nine children and became a midwife and healer who was sought after by many people. She was a devout Christian who, through prayer, could "draw fire and staunch blood." Hearing of a sick or injured person, she would lay hands on a child in her family on whatever part of the body the injury had been reported and pray. The person who had been injured would be cured. (WILDE.)

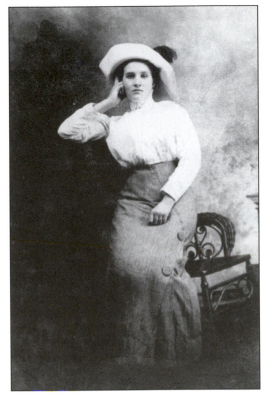

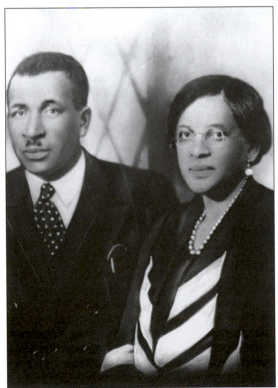

CLEVELAND AND ETTA HALL. This is a portrait of Selena Robinson's parents. Her father was the son of Miss Jane Hall and, with his wife Etta, he had 14 children. "D.C." Hall worked hard to support his large family. Etta Hall was only able to finish third grade initially because she had to go to work to support her family. But when Miss Agnes Hunt arrived in the county to teach children, Etta completed the seventh grade. She was so capable and talented that local physicians trained her as a nurse's assistant and midwife. She went on to deliver babies all over the county for many years. (Courtesy of Mrs. Selena Robinson.)

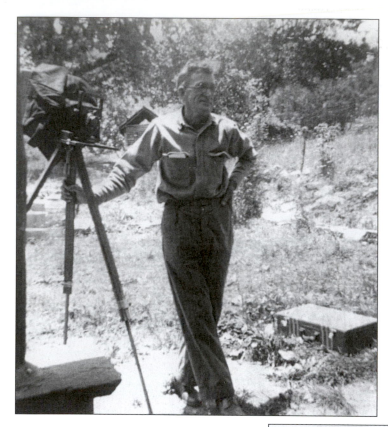

JOE WILDE IN THE 1940S. Joseph Stokely Wilde had worked in his family's photography studio in Knoxville, Tennessee. His interest in outdoor photography began while he was a student at Mars Hill College. After he married Ethel Phillips, a school teacher in Newport, Tennessee, they moved to Western North Carolina for her health. From the time they arrived in 1914, Wilde was taking pictures throughout the county. He would contract for tracts of timber from the lumber companies and his brother would oversee the men working while Wilde went off to take pictures. (WILDE.)

WILLIAM CHARLES AUSTIN. Austin came to the county in 1925 with his wife Mildred and two children. He had served his country in World War I and been disabled by mustard gas. He went to photography school after the war and lived in Waynesville for two years. The Austins opened Austin's Studio in downtown Brevard in 1925. They did portraits and developed all of the amateur roll film in the county. The shop struggled during the Depression when people could not afford photographs. But prosperity began to return with the arrival of Ecusta and in 1939, Austin's moved to its fourth location on East Main Street. When William and Mildred Austin were killed by a drunk driver in 1954, their four children returned to Brevard to run the studio, which expanded to include music and became Austin's Art Shop. When it closed in 1998, it was the oldest continuously run business in the county. (Courtesy of Pat Austin.)

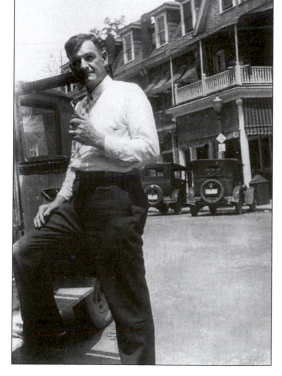

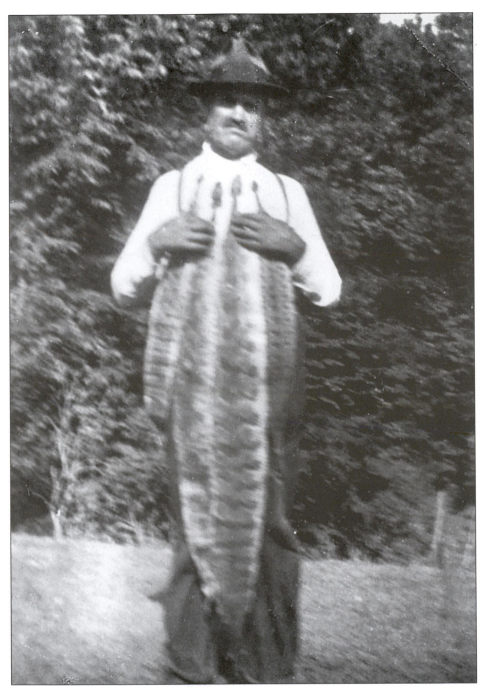

THE RATTLESNAKE MAN. Kim Miller killed over 2,000 rattlesnakes during his lifetime. He was famous enough for his rattlesnake hunting that *Life* magazine published a feature article about him. Known as "Uncle Kim," he lived in the Hogback Township between Brevard and Lake Toxaway. He stretched the hides and sold them, using the money for school clothes for his eleven children. He also used snake oil for arthritis and other conditions. He campaigned to get the road from Toxaway to the highway, which is now U.S. 64, paved. When completed, it was named for him. (HPC.)

BEULAH MAE ZACHARY. Beulah Mae Zachary was a founding member of Brevard Little Theater and the executive producer of a puppet show for kids called *Kukla, Fran, and Ollie,* which was on TV in the early 1950s. She was killed in a plane crash at LaGuardia Airport in February 3, 1959. She was flying from Chicago to New York City to work on the show. The plan crashed into the East River in heavy fog. (Courtesy of Dottie Vaniman.)

MOMS MABLEY. The daughter of James Aiken, Jackie "Moms" Mabley (1894–1975) was born Loretta Mary Aiken. She adopted a frumpy image onstage, yet she belittled old men and boasted of dates with young ones. She patterned her humor and her stage presence after her grandmother, Miss Jane Hall. Her performances include appearances at Carnegie Hall, the Apollo Theater, and the Cotton Club. She recorded nine popular albums for Chess Records, one of which sold over a million copies. (HPC.)

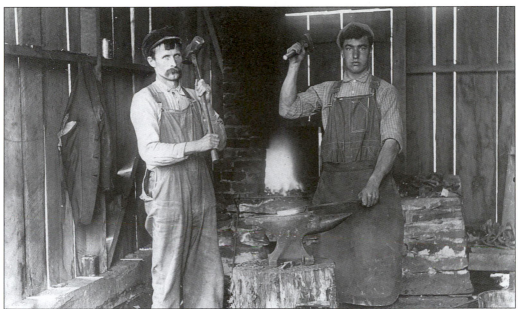

LOCAL BLACKSMITHS. Florida Fowler and George Morgan are pictured at Morgan's Mill blacksmith shop. There was also a blacksmith in downtown Brevard as late as the 1940s. Florida Fowler was the miller at Morgan's Mill as well. After the mill acquired a band saw with a huge belt, he came close to losing his son who got caught in the belt. Once he had discovered that his boy was trapped, it took 30 minutes to stop the great wheel's motion. The doctor arrived just as Fowler's son was taken down with a horribly crushed arm and body. Dr. Lyday made a body splint from the wood available and came to the house daily for months. The boy recovered with no visible impairment whatsoever. (HPC.)

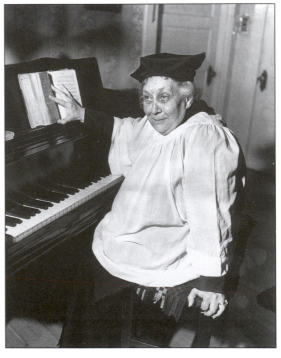

MOLLY ALLISON. "Aunt Molly" is seated at the piano in her home on Probart Street. She led the choir for many years at St. Philip's Episcopal Church. Jack Hudson remembers singing with the choir at eight years old (adults and children sang together). The reward for singing well was an orange Luden's cough drop. A former adult choir member remembers that in summer, the varnish on the church pews would become tacky with heat and the choir's surplices would make a ripping sound when they rose to sing. (AC.)

MISS SADIE NORTH. Miss Sadie is remembered as a fascinating woman who rode everywhere on her bicycle. She was written up in *Life* magazine in the 1950s. She taught swimming in the community and was a devoted member of the Red Cross. She carried her cat, Marco, in the basket on the front of her bicycle. (AC.)

"MISS HATTIE" KITCHEN. "Miss Hattie" Kitchen dressed up for the Centennial Celebration in 1961 in an outfit she had worn in a Brevard Little Theater production. She and her husband owned a store called "Nickel Bargain House" located in the alley between Main Street and Jordan Street. Local folks remember that she always appeared at her door with a decorated broom, which doubled as a walking stick. She kept a careful tally of the number of funeral wreaths displayed at each funeral. "Miss Hattie" drove a Thunderbird well into her 80s. (AC.)

JAMES GILLESPIE, 1822–1897. James was one of John Gillespie's 12 grandchildren and worked with the family gun-making business as did his father Matthew and his uncles and brothers. Each gun was made by an individual family member and each was marked with their initials. James marked his rifles with J.A.G. (Courtesy of the Jim Bob Tinsley Museum.)

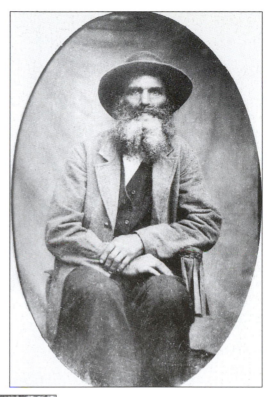

THE GILLESPIE RIFLE GUN. This rifle was known as "the most accurate gun in the world." It was lighter weight than the European rifles and was first manufactured by Pennsylvania gunsmith John Gillespie. He moved to Virginia, then South Carolina, and finally into North Carolina, where he set up a gun shop on the East Fork of the French Broad River. The rifle had a smaller bore and a longer barrel, which made it more accurate than any of its predecessors. Daniel Boone's beloved rifle "Bess" is thought to have been a Gillespie rifle gun. The Gillespies had six children. The daughters as well as the sons were sharpshooters. The Gillespie rifle can still be identified by its length and by the shape of the "tang," a piece of metal at the top of the stock. (Courtesy of the Jim Bob Tinsley Museum.)

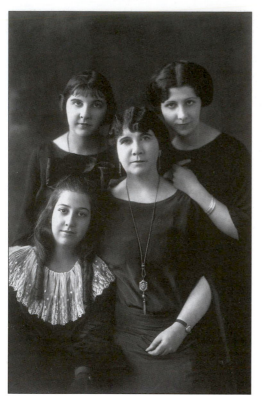

SILVERSTEEN MOTHER AND GIRLS. Elizabeth Silversteen poses flanked by her daughters, Miriam, Dorothy, and Adelaide. Elizabeth was intensely involved in the community of Brevard and in the life of St. Philip's Episcopal Church, where she was one of the first women members of the vestry. She was also extremely active in the Daughters of the American Revolution. Miriam, who was married to Albert Kyle and later to Alfred Weiss, managed her father's Brevard-based Transylvania Tanning Company. Dorothy was married to Capt. Thorwald Axel Bjerg of the Merchant Marine and lived for many years in Florida. They returned to Brevard in 1958 and she became a manager in her father's business. Adelaide "Babe" Silversteen VanWey (a stage name borrowed from an uncle) was a well-known singer and entertainer. She married Bill Hill, a vocal coach and accompanist. They lived in New York for 20 years where she sang both classical music and, later, folk music. They returned to Brevard in 1953 and Hill became manager of Gloucester Lumber Company. Adelaide died in 1968 at the age of 55. (Courtesy of Friends of Silvermont.)

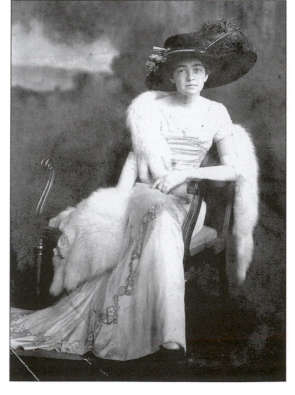

NANCY CLARKE CARRIER. She was the granddaughter of Phineas T. Barnum who founded the Barnum and Bailey Circus. She grew up on Goodwill Plantation near Columbia, South Carolina, but her family summered in the mountains. They named their summer home Rockbrook. Nancy's father purchased a car one summer from a dealership in Florida owned by a Mr. Carrier. The son, Henry Carrier, delivered the car to Brevard. He saw Nancy through the window and winked at her, which began a courtship that resulted in their marriage. They founded Camp Rockbrook on the estate in 1921, a girl's camp that continues today. (Courtesy of Mac Morrow.)

LACEY ALLEN. A much-loved Brevard citizen, Mr. Allen would pick up the mail at the railroad depot and haul it to the post office in a wheelbarrow. He could not read, but he never made a mistake with the mail. (Courtesy of Pat Austin.)

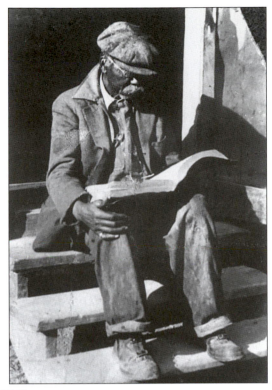

ETHEL K. MILLS. For many years, Mrs. Mills was principal of Rosenwald School. She was a beloved and respected teacher and administrator whose teaching principles are still valued and much quoted. "Teaching children to count is less important than teaching them what counts," was one of her aphorisms. She encouraged students to set high goals and to respect themselves and others, and she encouraged parents to "show interest in your children and don't leave it to the schools." (Courtesy of Pat Austin.)

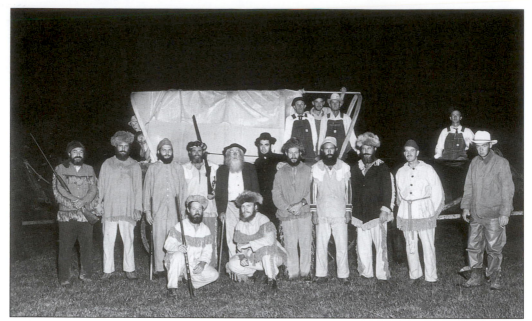

CENTENNIAL CELEBRATION, 1961. Local citizens dressed the part of their hardworking, frontier forebears. (AC.)

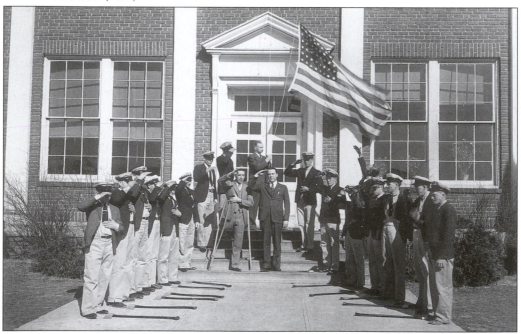

WOODMEN OF THE WORLD. Charles M. Douglas (on crutches) poses with the men standing at attention with their axes in front of them. They are presenting an American flag, probably to the principal of Rosman High School. Ernest "Coach" Tilson is standing on the left and lawyer Ed McMahan is at the right. The Woodmen organization provides insurance to its members and presents flags to community groups and schools as part of their many civic activities. The Woodmen are only one example of the many civic organizations that enriched Brevard and continue to do so. (HPC.)

EPILOGUE: 1861–1961

To sum up the birth and struggles and blossoming of a town in glimpses really is not possible. Yet as these photographs came together, the energy and uniqueness of Brevard kept bursting onto the page. Looking back, Pat Austin, who has lived here all her life, reflects that you can no longer go downtown to purchase necessities such as groceries and prescriptions. At one point, there were two department stores, two drugstores, a general store, hardware and feed stores, and three "five and dime" stores. She remembers when the ice man came once a week and farmers delivered produce as well as milk, eggs, and butter door to door by wagon. They would also plow the "victory gardens" of the city dwellers. But today, Brevard's downtown, while different, remains vital and alive, full of shops and galleries and restaurants. During the 1970s, 1980s, and 1990s, Brevard's industries were also alive and well. In the last two years, the city has lost three major industries. Yet the pull of the area persists, and people continue to come here to live and work just because they love the place. After all, how many places in the world can you be at a waterfall or a rushing stream in five minutes? How many places can you go to sleep at night and wake up in the morning watching the sun set and rise over the rim of the mountains? Over 200 years ago, naturalist William Bartram described the region in these words: "ridges of hills rising grand and sublimely one above and beyond another, some boldly and majestically advancing . . . whilst others far distant, veiled in blue mists, sublimely mount aloft, with yet greater majesty lift up their pompous crests and overlook vast regions." Some things never change.

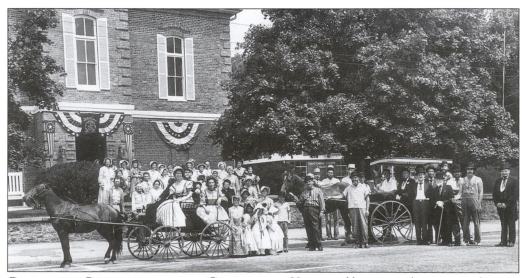

CENTENNIAL CELEBRATION AT THE COURTHOUSE. Horses and buggies and county residents in authentic costumes gather at the Transylvania County Courthouse to celebrate the first 100 years. (AC.)

BIBLIOGRAPHY

Barton, Tim. *A History of the Auger Hole: a report prepared for and funded by the Sierra Club's Pisgah Group.* 1998.

Harper, Francis. *The Travels of William Bartram.* New Haven: Yale University Press, 1958.

Kersh, Earle. *Old Transylvania Times.* Brevard, NC: The Transylvania County Joint Historical Preservation Commission, 1997.

Lefler, Hugh Talmage and Albert Ray Newsome. *The History of a Southern State: North Carolina.* Chapel Hill, NC: The University of North Carolina Press, 1954.

McCrary, Mary Jane. *Transylvania Beginnings: A History.* Brevard, NC: The Transylvania County Joint Historical Preservation Commission, 1984.

Phillips, Laura and Deborah Thompson. *The Architectural History of a Mountain County.* Brevard, NC: The Transylvania County Joint Historic Preservation Commission, 1998.

Penny Postcards through the Years. Brevard, NC: The Transylvania County Historical Society.

Tinsley, Jim Bob. *Land of Waterfalls, Transylvania County, North Carolina.* Kingsport, Tennessee: Kingsport Press, 1988.

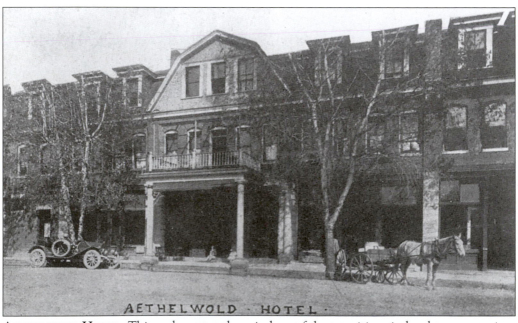

AETHELWOLD HOTEL. This early postcard reminds us of the transitions in local transportation, not to mention in local lives and fortunes, occurring in the early 20th century. (HPC.)